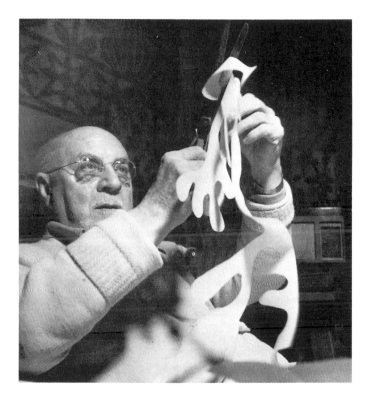

matisse

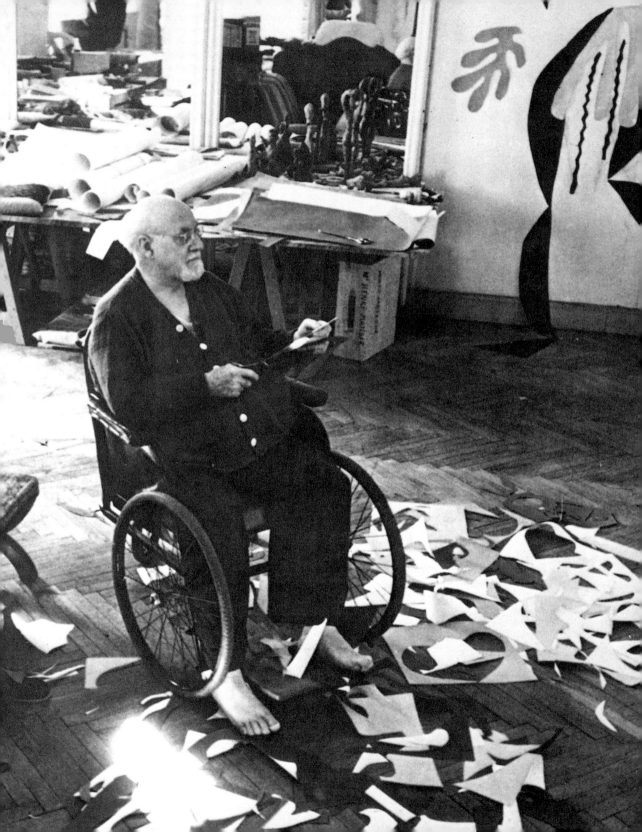

Henri Matisse
Cut-outs

Text by
Gilles Néret

Benedikt Taschen

Cover:
The Sword-Swallower (Jazz),
1943–1946. Stencil

Back cover:
Matisse in Tahiti, 1930

Endpapers:
The Lagoon (Jazz), 1944. Stencil

Page 1:
Matisse and his scissors, Vence, 1947

Page 2:
Matisse at work in his Nice studio, 1952.
On the wall *The Negress* can be seen in
a preliminary stage.

Pages 4–5:
Matisse's drawing and manuscript text
for *Jazz*

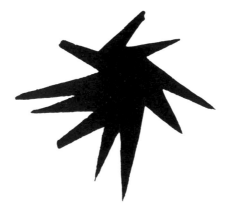

**This book was printed on 100% chlorine-free bleached
paper in accordance with the TCF standard.**

© 1994 Benedikt Taschen Verlag GmbH,
Hohenzollernring 53, D-50672 Köln
© for the illustrations: 1994 VG Bild-Kunst, Bonn/
Succession H. Matisse
Text and design: Gilles Néret, Paris
Cover: Angelika Muthesius, Cologne
English translation: Chris Miller, Oxford

Printed in Germany
ISBN 3-8228-9040-5
GB

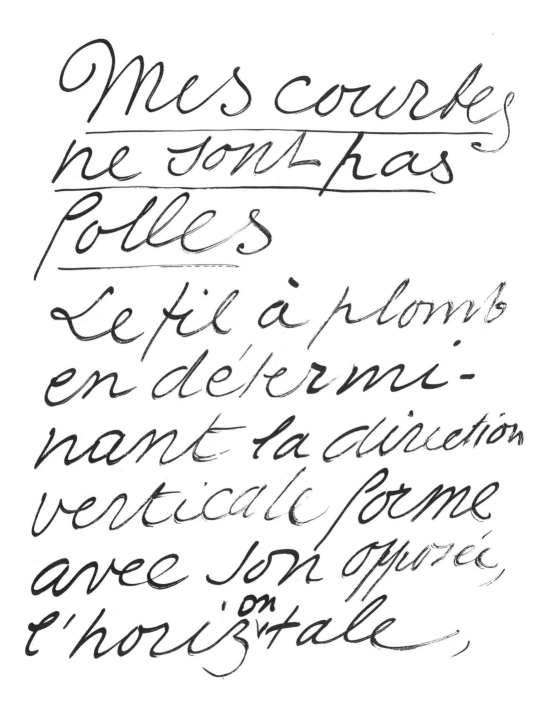

Mes courtes ne sont pas folles

Le fil à plomb en détermi-
nant la direction
verticale forme
avec son opposée,
l'horizontale,

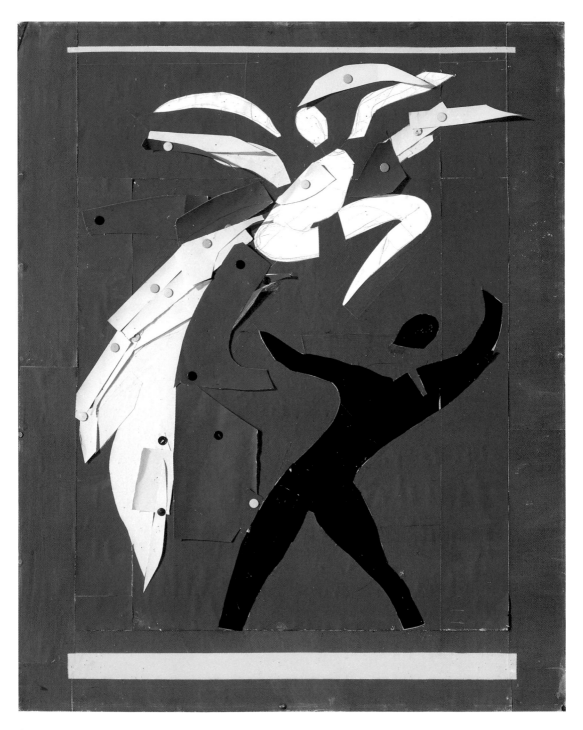

6

HENRI MATISSE
"Genius is just childhood one can return to at will"

S outh Pole, North Pole": thus Picasso is said to have defined the century's two most illustrious painters, those who played the greatest role in 20th century painting. Matisse and Picasso were indeed great rivals, their relations over half a century founded on discreet friendship if not indeed complicity. The poet of colour found his counterpart in the breaker of forms. "I feel through colour," said Matisse, "so my pictures will always be organised by it. Yet this requires that the sensations be condensed and that the means employed be brought to their utmost expressivity."

One of the hallmarks of a truly great artistic œuvre is that it never stops at the discoveries it has made but immediately sets out in new directions. A single arc, the product of a single intention, this diversity can sometimes disorientate. When an artist further uses all the forms of expression – painting, drawing, and sculpture – simultaneously, the disorientation can border on bewilderment. For Matisse, in his quest to refine form and exalt colour, the end justified the means, and he offered revolutionary solutions under the guise of classical appearances in the best tradition of French painting. It is this apparently innocuous revolutionary aspect that some still fail to perceive: this poised art, full of purity and calm mastery, this "joy in painting the beauty of the universe" stand out so clearly in an epoch when the absurd, the unquiet, the "convulsive" reigned supreme. The gouache cut-outs from the end of his life have also been misunderstood. They have been taken for the last hobby of a crippled old man, whereas they are, like Matisse's Chapelle du Rosaire at Vence (pp. 54–57), "the end-product of an entire life of work and the flowering of an enormous, sincere, and difficult effort", of a life devoted to exalting colour and evoking the happiness of living and painting, which were, for him, inseparable. For the gouache cut-outs are continuous with a purpose from which the artist never departed after he had found himself as a fauve: the work is born of the untrammeled confrontation of colours.

Around 1943, in Cimiez and later at Vence, in the sunlit South of France, Matisse felt that he had said all he had to say in painting. And he found colour difficult to manipulate be-

Dance, 1938. Gouache cut-outs, 80 x 65 cm. Centre National d'Art et de Culture Georges Pompidou, Paris

To solve the problem presented by the composition of the enormous work for Dr Barnes, Matisse for the first time had the idea of cutting out pieces of coloured paper, which he could then move around at will, like a stage director, till he had found the right positions for them. Unfortunately, as there was an error in the dimensions specified, Matisse had to make a second version. There was a silver lining to this cloud for the Musée d'Art Moderne de la Ville de Paris, which possesses the first version.

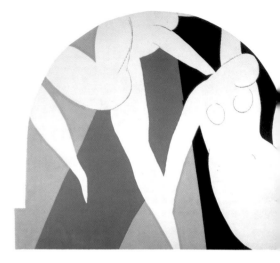

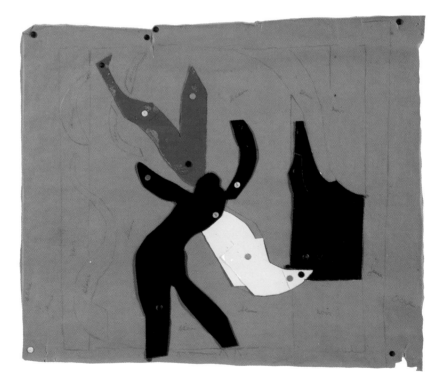

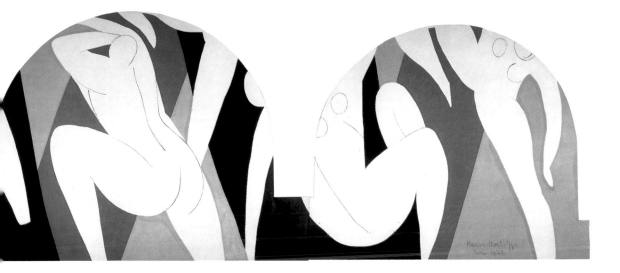

cause of his illness. It was then that he first had recourse to sheets of paper precoloured with gouache which he could cut to the shapes he desired. The result: the extraordinary *Jazz* album (published in 1947), "improvisations in colour and rhythm" – like those of a Louis Armstrong or a Charlie Parker – in which Matisse's memories of the circus, of popular stories and of his travels took form in vivid, violent images. To link them and to mitigate the contrasts between them, Matisse wrote an accompanying text, in a large, harmonious script (pp. 5 and 30), full of striking phrases: "Sculpting the living colour reminds me of the direct carving of the sculptors… My curves are not mad…"

Incredible man! He was now confined to his rocking chair or his bed and was, it might be thought, lost to painting. Yet he again found a way to transcend the art of drawing, grasping the desired opportunity to work towards a perfect synthesis of everything he had learnt. With nothing more than a pair of scissors and paper precoloured to precisely the shades that he had had prepared, he solved the problems of form and space, outline and colour, structure and orchestration which he had always sought to harmonize. Still more, this new enterprise at last

Dance (first version), 1931–1933. Oil on canvas, a) 340 x 387 – b) 355 x 498 – c) 333 x 391 cm. Musée d'Art Moderne de la Ville de Paris

Page 8 bottom:
Dancer. Study for the curtain of the ballet *Strange Farandole* (subsequently retitled *Red and Black*), 1937. Pencil and gouache cut-outs, 58.5 x 69.8 cm. Centre National d'Art et de Culture Georges Pompidou, Paris

9

allowed him to accord full importance to line rhythms and to forms, which he had often in the past had to sacrifice to colours and tonal relations.

Here, realism and abstraction were reconciled at the endpoint of a long process that grew out of its own logic and not, as some defenders of abstract art have impudently asserted, out of carelessness or the temptation to climb onto some contemporary bandwagon. Matisse laid all ambiguity to rest when he wrote that he "drew in colour", and when he stated to André Lejard "I am currently focusing on material more matt and more immediate, and this leads me to seek a new means of expression. Paper cut-outs allow me to draw in colour. For me it is a question of simplification. Instead of drawing the outline and establishing colour within it, I draw directly in the colour, which is more exact for not being transposed. This simplification guarantees precision as I reconcile two means now become one... It is not a beginning, it is an endpoint."

Olympian amusement, twilight bedazzlement, the frivolity of the sage... hasty remarks and judgements about the painted

From modelling clay to carving directly into the colour, Matisse's work is that of a sculptor ...

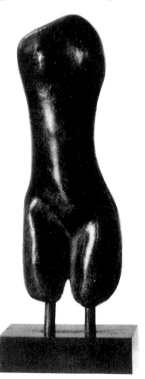

paper cut-outs have proliferated. Indeed, Georges Duthuit acknowledges that there may be some truth in them, a truth "equally applicable to Goethe chatting with Eckermann or to the titanic author of *The Magic Mountain* leaving an unfinished picaresque novel". If there is, it is no less true to see in Matisse one of those "great artists grown old" of whom Barrès speaks, artists who, "hastening to explain themselves, contracting their means of expression as they shortened their signature", have attained "the concision of enigmas or epitaphs".

Despite the considerable international acclaim that greeted *Jazz*, Matisse was not at first satisfied. It was some time before he grew used to the transposition by stencil printing to which his publisher Tériade subjected the cut-outs; they could not otherwise be reproduced. The technique is not perfectly accurate, but it has its use today, for some of the cut-outs have since faded, and we now look to Tériade's stencils for the truth of Matisse's colours. Matisse, in 1944, wrote to Tériade about *Jazz*, that "this twopenny ha'penny toy is wearing me out and my whole being revolts at its invasive growth!"

Page 10 left:
Small Torso, 1929. Bronze, height: 9 cm

Page 10 right:
Small Thin Torso, 1929. Bronze, height: 7.8 cm

Bottom:
Forms. White Torso and Blue Torso (Jazz), 1944. Stencil

A grave difficulty faced the critics: this new way of painting could not be related to any that had come before. It was a new approach; it had never been used before. It could not even be compared to the Cubist collages (Picasso, p. 13 right), which were intended to present the spectacle of a geometry created from various and unexpected materials. Nor to the biomorphic signs of Arp or the abstract vocabulary of Kandinsky (p. 12 right). Yet it was enough to recall the early Matisse, the fauve who wanted a "work born of the untrammelled confrontation of colours". *Dance* and *Music* executed for Shchukin, and the *Dance* commissioned by Dr Barnes (pp. 8–9), the latter designed by pinning paper cut-outs, should have given the game away; all of these exhibited wide surfaces free of small-scale colour. As to sculpting in colour, we need only put the plate from *Jazz* entitled *White Torso and Blue Torso* (p. 11) alongside the *Small Torso* and *Small Thin Torso* of 1929 (p. 10) to see how it is done.

Only a Matisse who had already mastered both sculpture and painting could be so daring as to apply the technique of the sculptor to the substance of painting, and carve a block of pure colour. It was the more natural for him because drawing with a pair of scissors implied no real change in his aesthetic. "There is no discontinuity," he explained, "between my former paintings and my cut-outs; only with more absoluteness and more

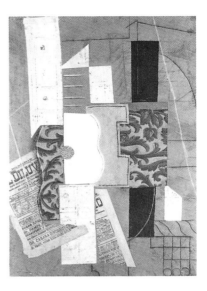

M atisse's method was entirely new. It had never been used before. It cannot be categorised; it is neither Cubist (Picasso) nor abstract (Kandinsky) nor Dadaist (Arp).

Page 12 left:
Jean Arp: Collage, 1941–1942.
Collage and oil, 18.5 x 24.6 cm.
Kunstmuseum, Basle

Page 12 right:
Wassily Kandinsky: Succession,
1935. Oil on canvas, 80 x 100 cm.
The Phillips Collection, Washington

Top:
Pablo Picasso: Guitar, 1913.
Glued paper, 66 x 49 cm. YT – The
Museum of Modern Art, New York

Left:
Chinese Fish, 1951. Gouache
cut-outs, 192 x 90 cm

abstraction, I have attained a form filtered down to the essential, and, of the object that I formerly presented in the complexity of its space, I have retained the sign that is sufficient and necessary to make it exist in its own form and for the whole in which I have conceived it."

In a 1945 text for *Verve*, entitled "On Colour", Matisse wrote about Ingres and Delacroix: "Both express themselves by 'arabesques' and by 'colour'." He had discovered a point com-

The Sadness of the King, 1952.
Gouache cut-outs, 292 x 396 cm.
Centre National d'Art et de Culture
Georges Pompidou, Paris

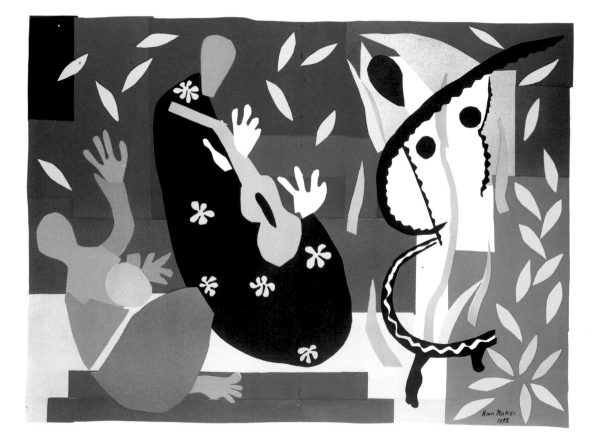

mon to two very different painters. It was a point dear to his heart, and he detected it in others: "Gauguin and Van Gogh will later be seen to have lived by the same rhythm: arabesques and colour!" But before Matisse, no-one had taken the association between colour and arabesques so far, to the point of reducing

The Negress, 1952–1953. Stencil

This is the black dancer, Josephine Baker, queen of the Roaring 20s and 30s, famous for appearing on stage wearing nothing but a belt of bananas.

the canvas to these two modes of expression. Till then, the draughtsman and colourist had complemented each other in a more or less equal partnership; now they could work together on an equal footing, in an osmosis in which each maintained the autonomy of his vision. In this way, Matisse remade for himself Braque's dictum that "Form and colour do not merge; there is simultaneity".

The artist confided to Alfred Barr that, no longer able to

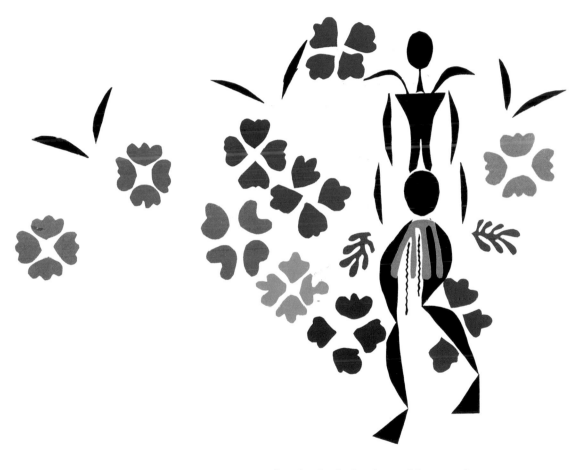

move or swim, he had, thanks to his gouache cut-outs, surrounded himself with water and extraordinary gardens, pinning the maquettes of his works to the walls of his appartment (p. 91) and spending his days contemplating and transforming them. These are scenes and landscapes that go "beyond" any scene or

15

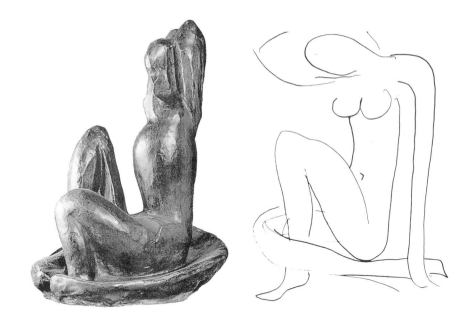

Left:
Venus with Shell, 1930. Bronze,
height: 31 cm

Right:
Study for *Blue Nude*, 1952.
Ink. Private collection

Page 17:
Blue Nude I, 1952. Gouache
cut-outs, 116 x 78 cm. Galerie
Beyeler, Basle

landscape and even any "work". The "beyond" evoked by the
last works took the form of that poignant and yet serene adieu
The Sadness of the King (p. 14). This picture is the last great
pictural effort by Matisse to be made in pasted gouache cut-
outs. It is the last salute by the artist – who is represented by the
sombrely clad king, guitar in hand – to the world around him,
to the themes he loved. Matisse has drawn them all around him,
down to the last woman dancer, as if to have himself buried
with them like an Ancient Egyptian Pharao. "You are going to
simplify painting!", the prediction of his master, Gustave
Moreau, had been fulfilled to the letter, in the brass fanfares of
Fauvism and in the final sustained chord of the cut-outs. At the
approach of death, Matisse was proud that he "could at last sing
like a child following the impulses of his heart from the top of
the mountain he has climbed". As Baudelaire had already
stated: "Genius is just childhood to which one can return at
will."

But let us leave the last word to Matisse himself, writing, at
83, to his dear friend Rouveyre: "My survival in my works, that
I desire… I never think of it, for, having thrown the ball as best
I could, I cannot be certain whether it will fall on land or sea or
into that precipice from which nothing ever returns."

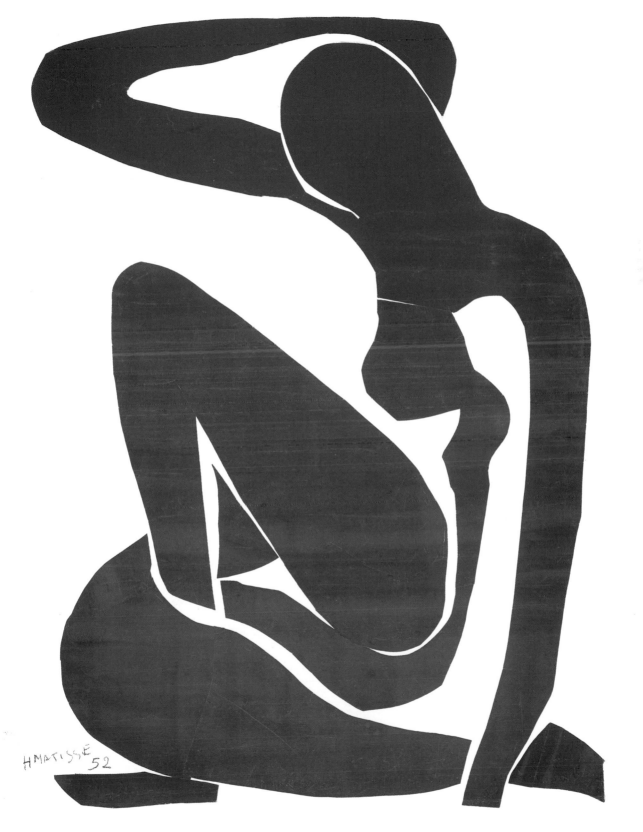

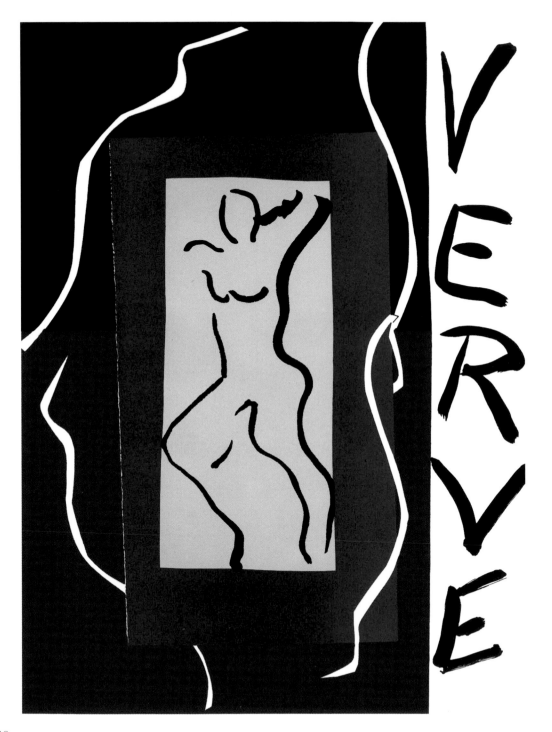

18

An Ideal: Life Itself

Matisse, the famous painter, and Tériade, the as yet little known publisher of *Verve*, shared an ideal: for both, painting was life itself. Hence the enthusiasm with which Matisse created this cover, cutting out its elements from printing-press samples. He himself executed the calligraphy with paintbrush and Indian ink. Tériade then lithographed the composition in the workshops of Fernand Mourlot.

Page 18:
Gouache cut-outs for the cover the 1st number of *Verve*, 1937

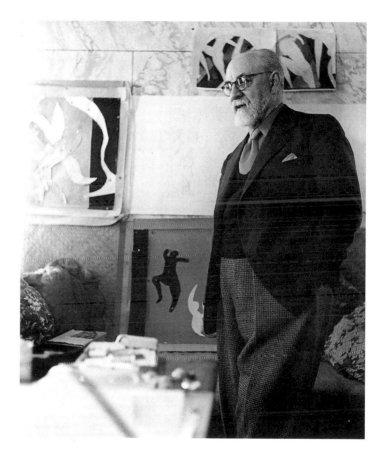

Matisse in Nice in 1937–1938. On the wall, to the left, a stage curtain for *Strange Farandole*; in the centre *Two Dancers*.

19

M atisse's fear that his intentions would be betrayed by colour printing were assuaged by the success of this, the thirteenth number of *Verve*. Thus fortified, his collaboration with Tériade continued for over two years, during which the *Jazz* project was conceived, along with plans for illustrations to *The Portuguese Nun* and *Charles d'Orléans*.

Top:
Cover for the 13th number of *Verve*, 1945

Right:
Two Dancers, 1938. Gouache cutouts, 81.5 x 65 cm. Sketch for the curtain of *Strange Farandole*

Page 21:
The Toboggan (Jazz), 1943. Stencil

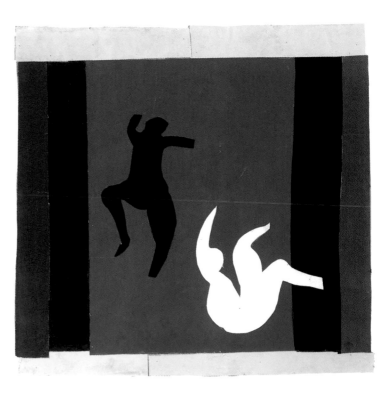

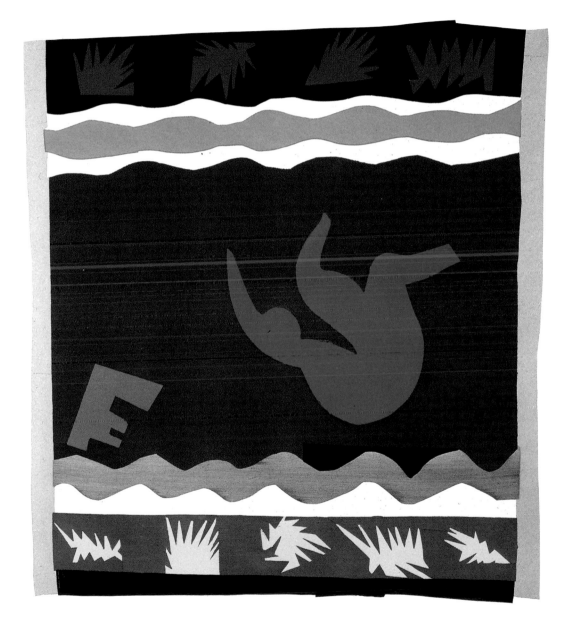

First version of curtain for *Strange Farandole*, 1938. Gouache cut-outs, 61 x 61cm. Private collection

Programme cover for the ballet *Strange Farandole*

Drawing for the costumes of *Strange Farandole*

Strange Farandole was given its première in Monte Carlo by the Ballets Russes. The score was the 2nd Symphony of Shostakovich, the choreography was by Léonide Massine and the costumes by Matisse. The ballet's subject was the eternal struggle between spirit and matter. A couple of dancers were clad in white by Matisse to symbolize the spirit of poetry resisting

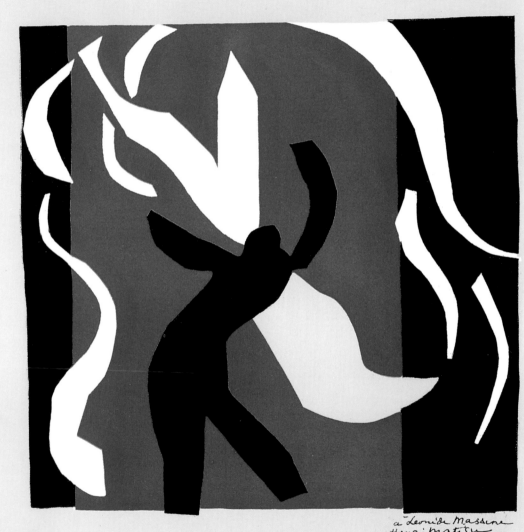

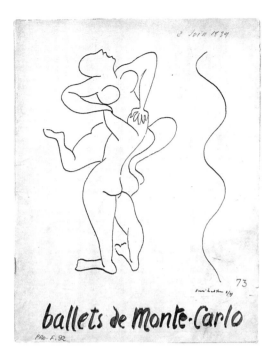

ballets de Monte·Carlo

the attacks of black or red figures symbolizing brutal and evil forces. Man succeeds in dominating them temporarily before succumbing to his "Destiny"; the figure of Destiny made a very similar appearance in *Jazz* (p. 41).

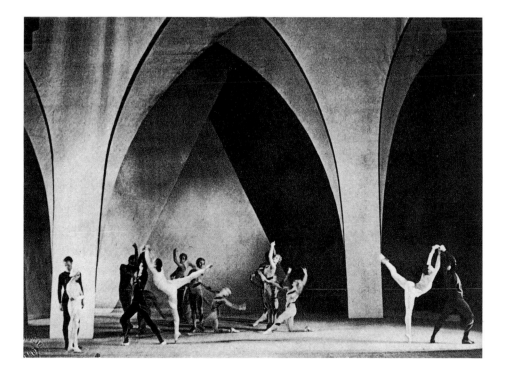

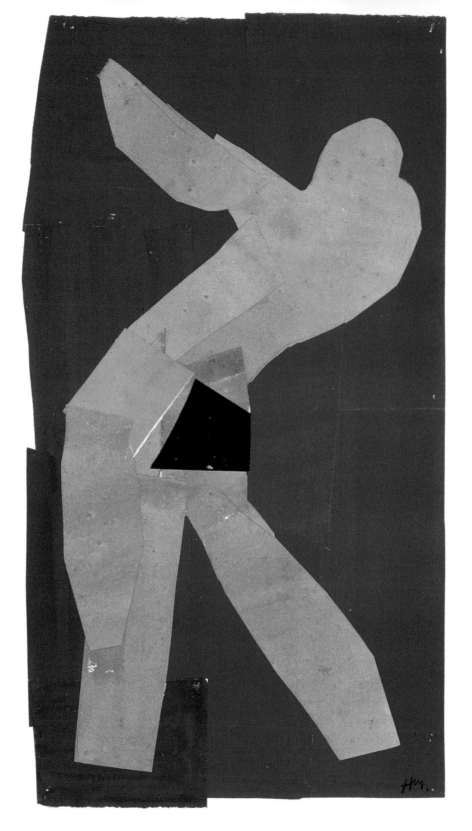

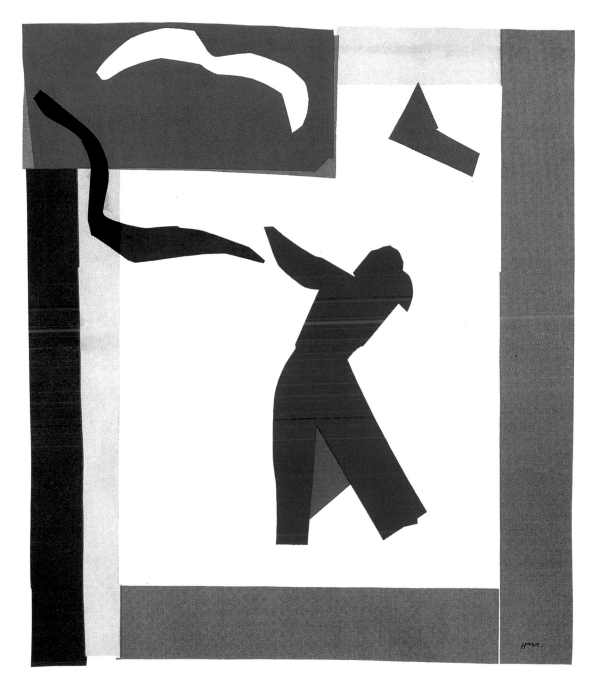

Red Dancer, 1938. Gouache cut-outs, 75 x 62 cm. Private collection
Page 24: Small Dancer on Red Background, 1938. Gouache cut-outs, 37 x 19 cm. Private collection

Calligraphic title by Matisse for *Jazz*

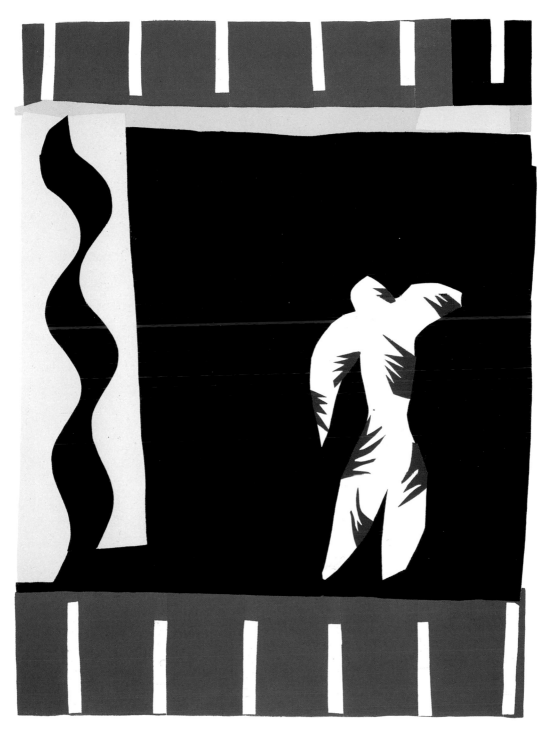

The Clown (Jazz), 1943. Stencil

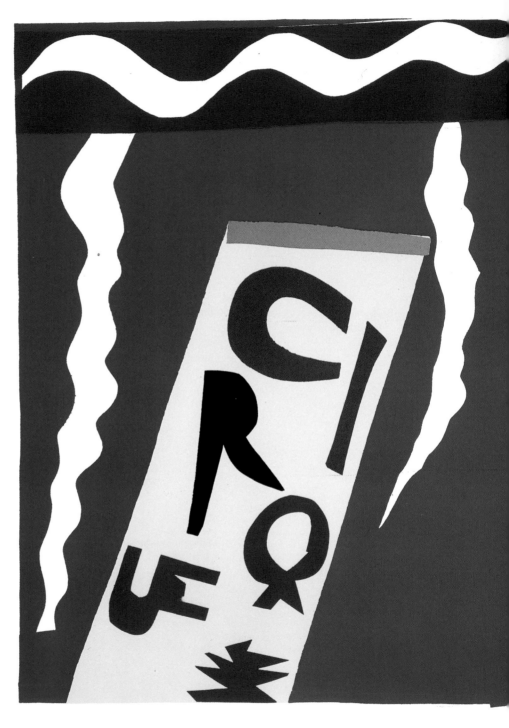

The Circus (Jazz), 1943. Stencil

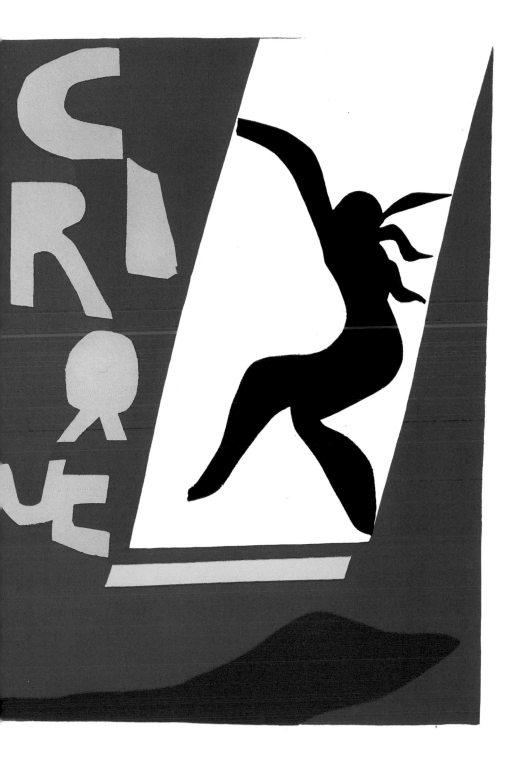

Ces pages ne
servent donc
que d'accompa-
gnement à
mes couleurs,
comme des
asters aident
dans la compo-
sition d'un
bouquet de

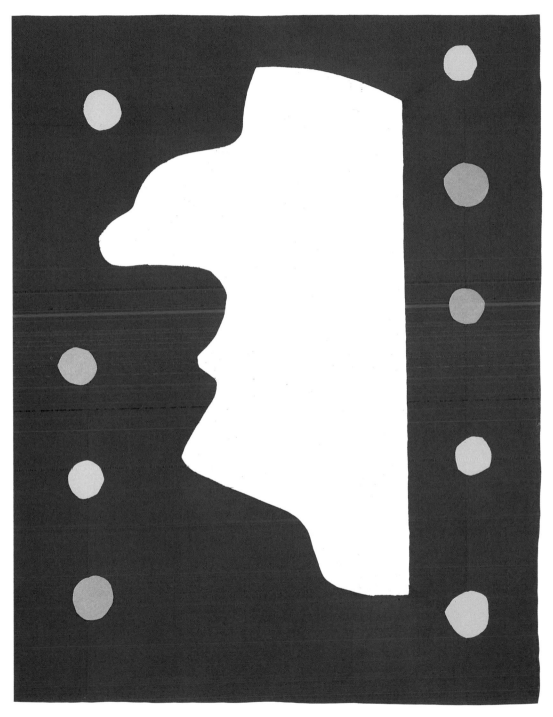

Mr Loyal (Jazz), 1943. Stencil

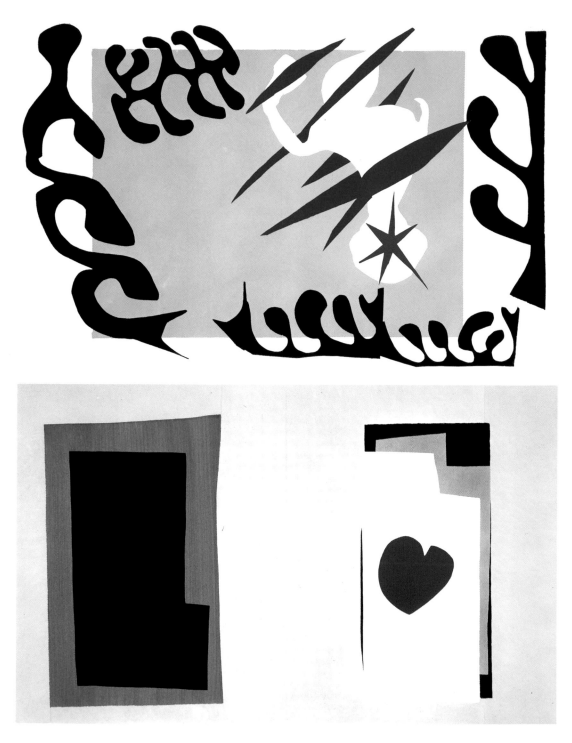

The Nightmare of the White Elephant (Jazz), 1943. Stencil

The Heart (Jazz), 1943–1944. Stencil

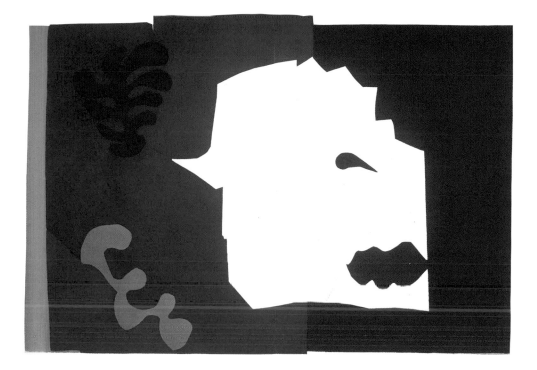

I. Le clown page 6

II. Le cirque p. 14

III. Monsieur Loyal p. 19

IV. Le cauchemar de l'Éléphant blanc p. 26

V. Le cheval l'écuyère et le clown p. 34

The Wolf (Jazz), 1944. Stencil

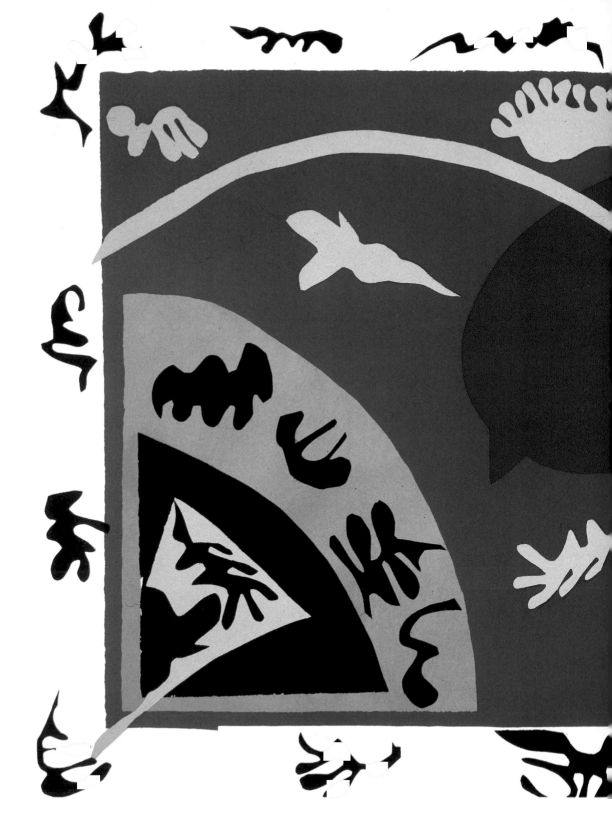

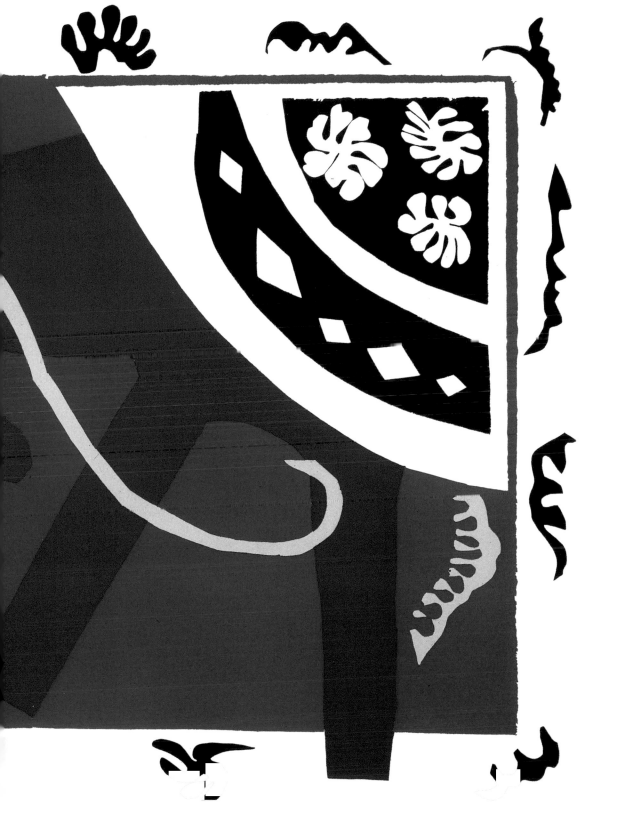

Pages 34/35:
The Horse, the Squire and the Clown (Jazz), 1943–1944. Stencil

Right:
Apocalypse of Saint-Sever, 12th century. Folio 139

Page 37:
Icarus (Jazz), 1943. Stencil

Pages 38/39:
The Burial of Pierrot (Jazz), 1943. Stencil

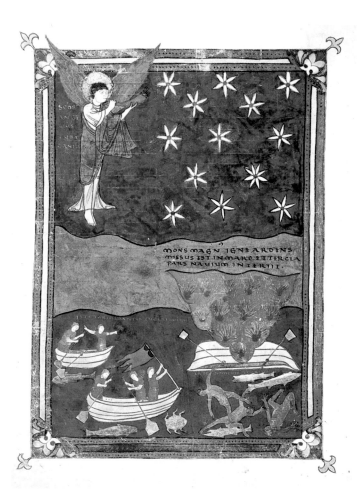

Sculpting the Living Colour

Jazz was published by Tériade Editeur in Paris, in 1947, in a big infolio volume measuring 42 x 32.5 cm. The twenty colour plates were stencil printed in 170 copies after the gouache cut-outs by Matisse, using the same Linel inks as the artist. *Jazz* offers a complete repertory of forms. The many-pointed stars, the leaves, and the seaweed with its deep undercuts; these recur throughout the plates like a leitmotif. Curiously enough, these same forms, or their ancestors, can be found in a 12th century illuminated manuscript, the *Beatus of Saint-Sever*. We can be certain that Matisse knew the *Beatus*, which Mourlot, his engraver, had lithographed. There is no doubt that *Icarus* and other plates from *Jazz* owe a considerable debt to the *Beatus*, which was, in its time, one of the major sources of Romanesque sculpture. Had not Matisse claimed that he wanted to "sculpt the living colour"?

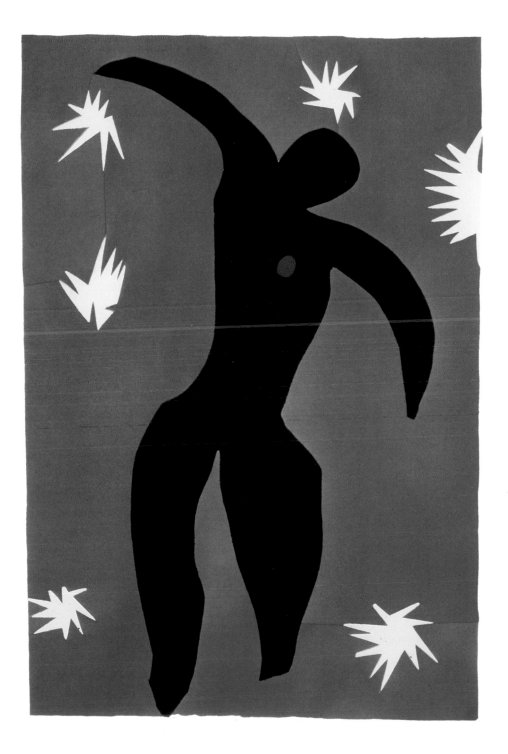

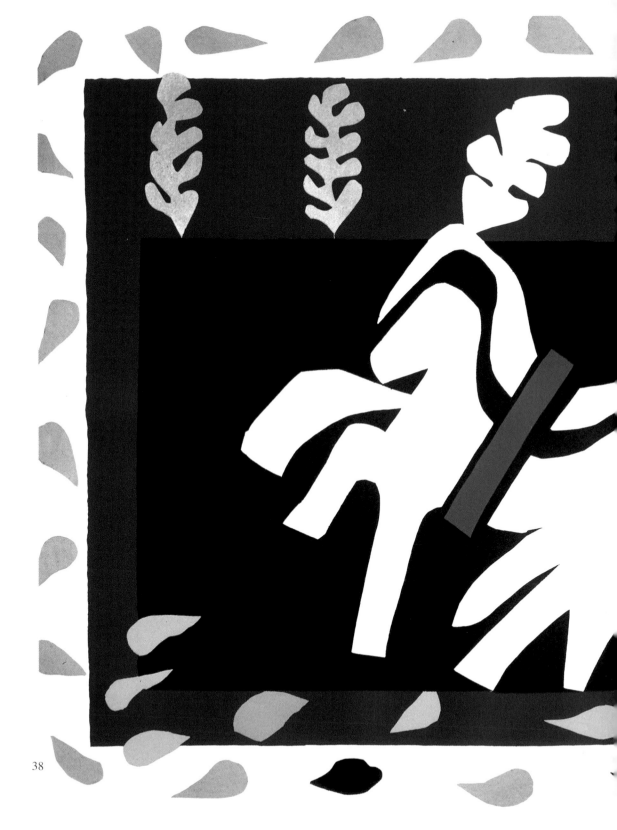

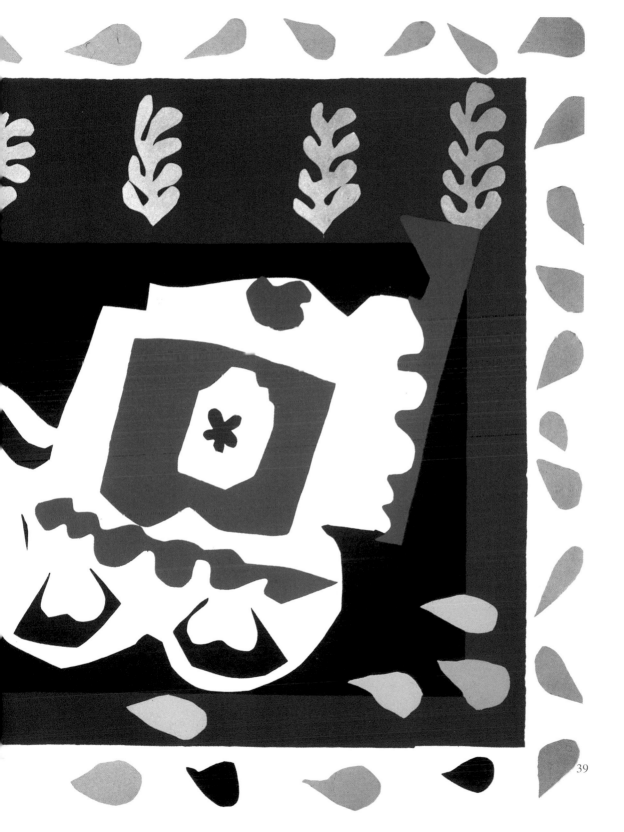

39

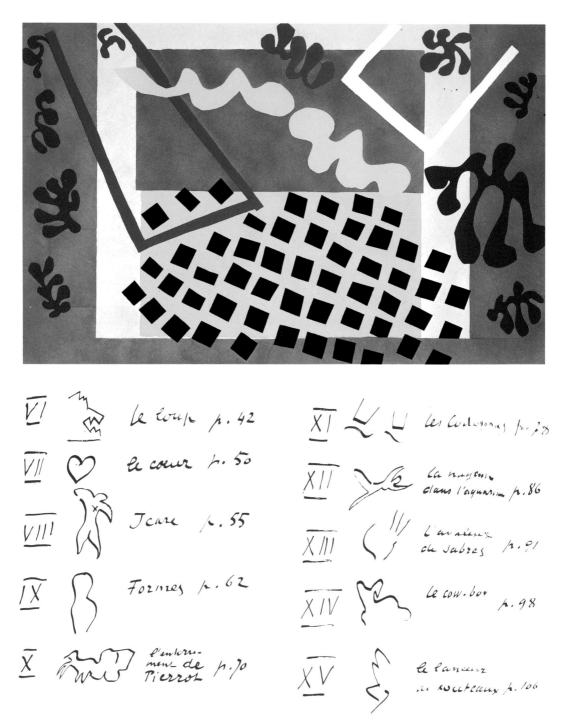

VI ⚡ le loup p. 42

VII ♡ le cœur p. 50

VIII Icare p. 55

IX Formes p. 62

X l'enterre-
ment de
Pierrot p. 70

XI Les Codomas p. 78

XII La nageuse
dans l'aquarium p. 86

XIII L'avaleur
de sabres p. 91

XIV Le cow-boy p. 98

XV Le lanceur
de couteaux p. 106

The Codomas (Jazz), 1943. Stencil

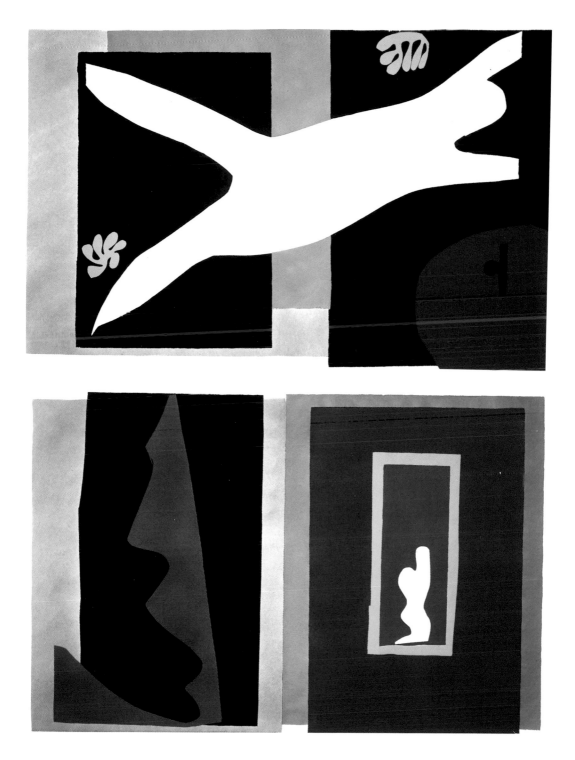

The Woman Swimming in the Aquarium (Jazz), 1944–1946. Stencil Destiny (Jazz), 1943–1946. Stencil

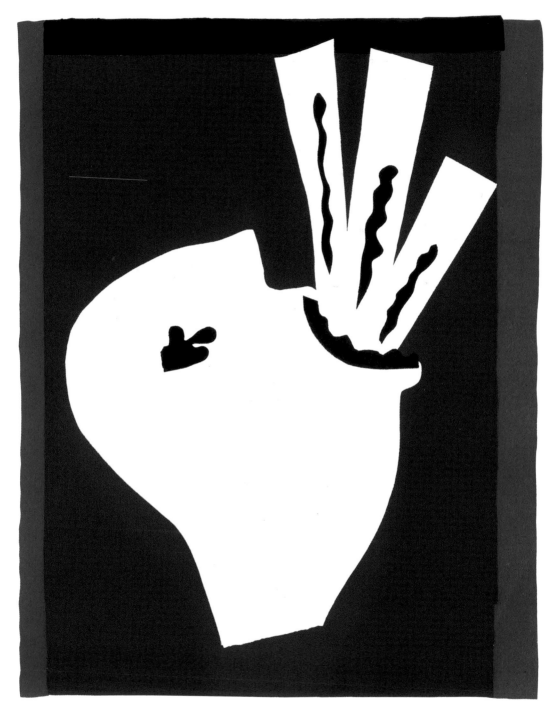

Page 42:
The Sword-Swallower (Jazz),
1943–1946. Stencil

Bottom:
The Cowboy (Jazz), 1943–1946.
Stencil

Pages 44/45:
The Knife-Thrower (Jazz),
1943–1946. Stencil

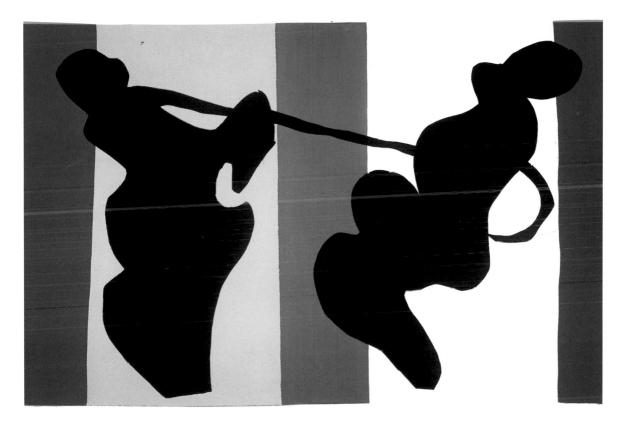

Juggling with Forms

Concerning his illustrations to Mallarmé's poems, Matisse wrote: "I compare my two pages to the objects chosen by a juggler. Let us imagine, in relation to this question, a white ball and a black ball and on the other hand two pages, the light and shade so very different and yet side by side. Despite the difference between the two objects the art of the juggler makes a harmonious whole in the eyes of the spectator." In the same way, Matisse explained that, undecided what what to put between the works in *Jazz*, he chose handwritten texts as another form of "juggling".

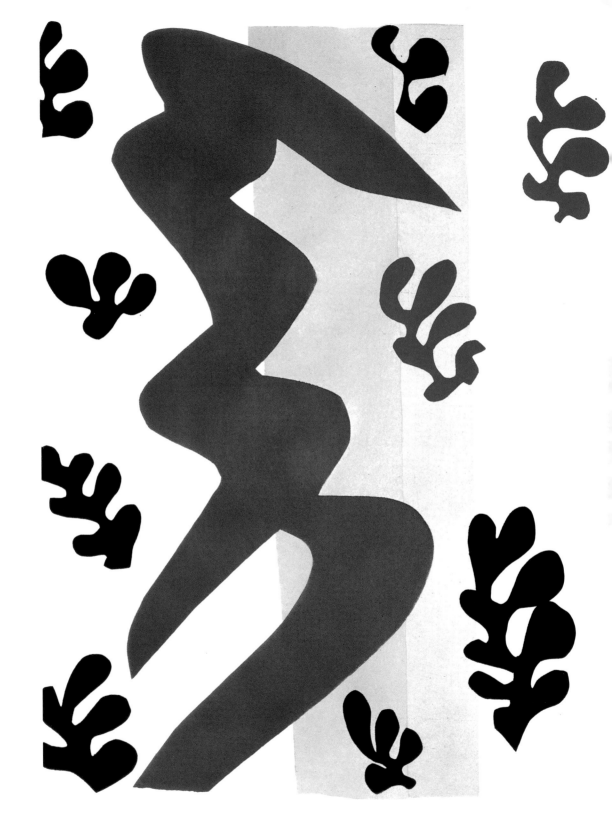

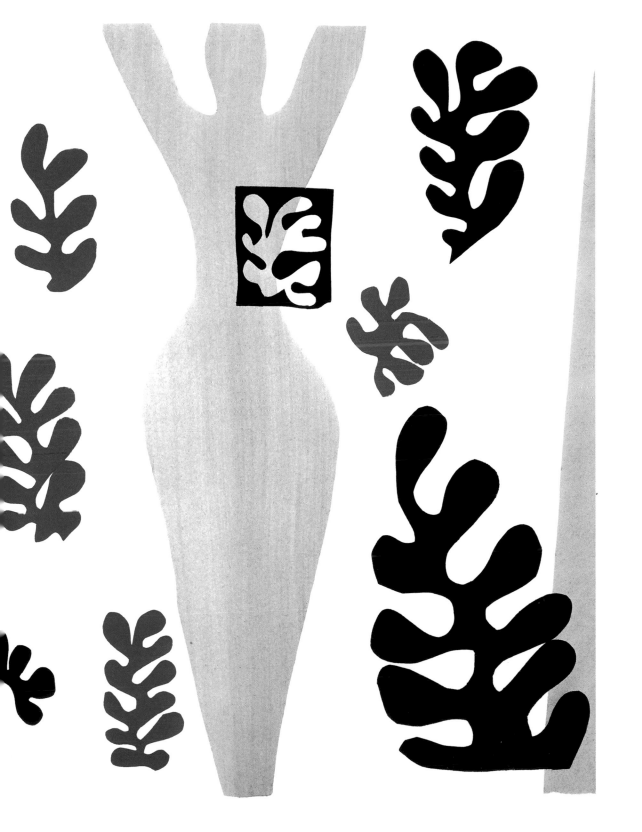

XVI le destin p. 114

XVII le lagon p. 122

XVIII le lagon p. 130

XIX le lagon p. 138

XX le tobogan p. 143

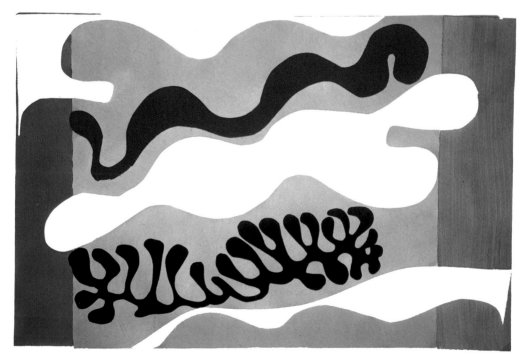

The Lagoon (Jazz), 1944. Stencil

The Lagoon (Jazz), 1944. Stencil

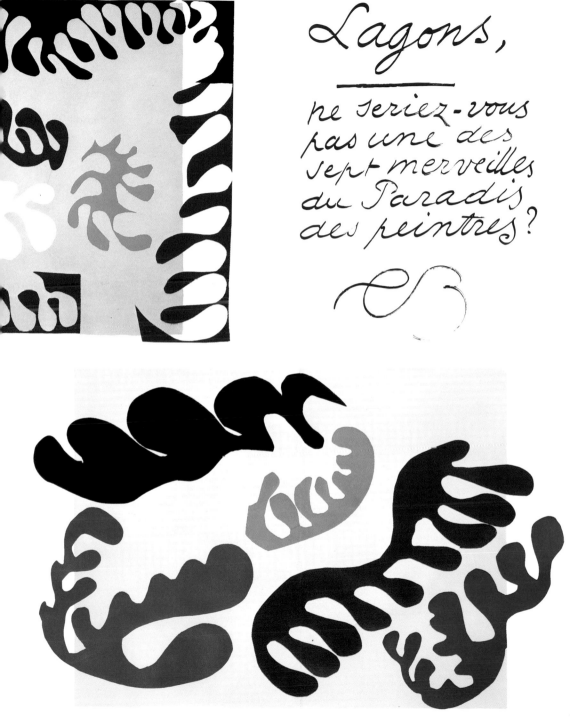

Lagons,

ne seriez-vous
pas une des
sept merveilles
du Paradis
des peintres?

The Lagoon (Jazz), 1944. Stencil

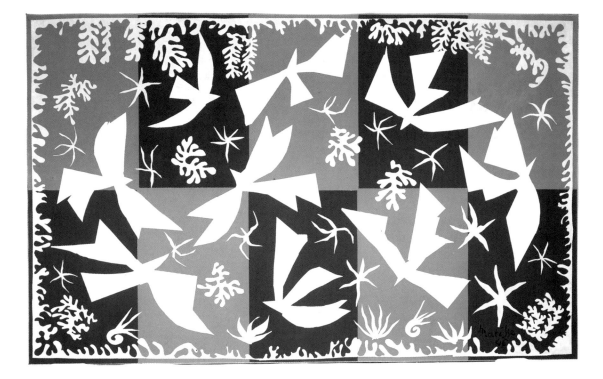

Polynesia, the Sky, 1946. Gouache
cut-outs, 200 x 314 cm. Centre Na-
tional d'Art et de Culture Georges
Pompidou, Paris

Right:
The Budgerigar and the Siren and
Christmas Night on the walls of
Matisse's appartment in Nice, 1953
Page 49:
Christmas Night. Maquette of the
stained glass window for *Life*,
1952. Gouache cut-outs,
335 x 135 cm. The Museum of
Modern Art, New York

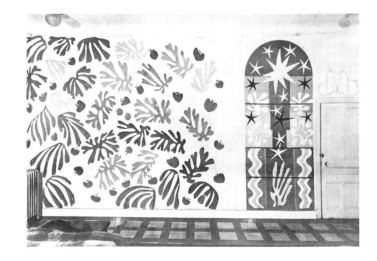

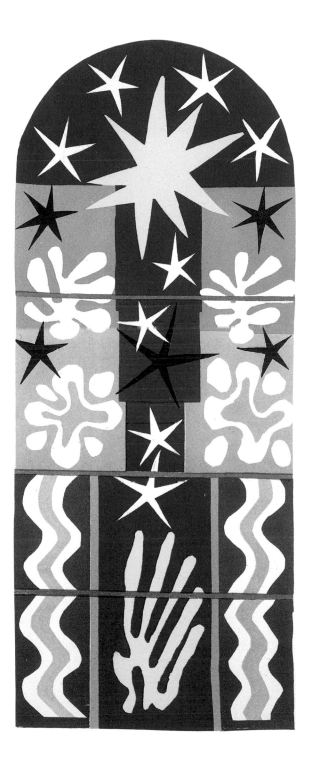

Like a Flight of Doves

After *Jazz* came a proliferation of gouache cut-outs of increasing size, which became first tapestries, then stained-glass windows or swimming-pool mosaics. One such is *Polynesia*, which is almost four metres in length and resulted from a commission by A. Ascher of London for a wall-hanging. "These successive flights of doves, their orbs and their curves glide within me, as if in a vast inner space," Matisse confided to André Verdet. "The sensation of flight released in me helps to guide my hand when it directs the trajectory of my scissors. It is difficult to explain. I would say that it is a sort of linear, graphic equivalent to the sensation of flight. There is also the question of vibrant space."

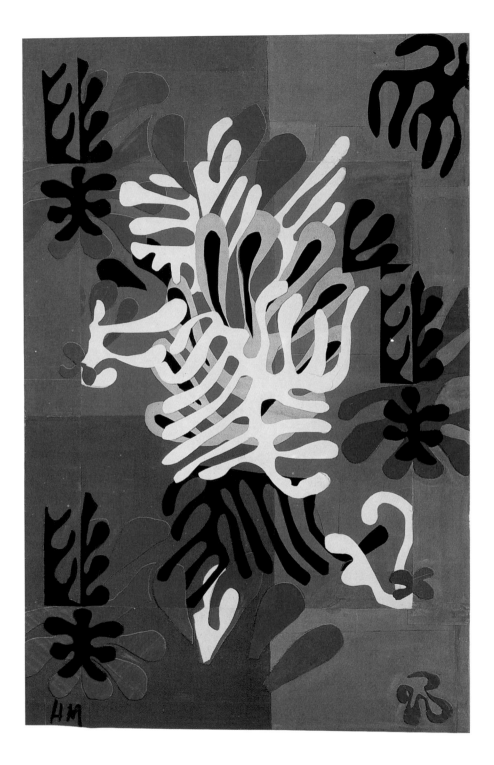

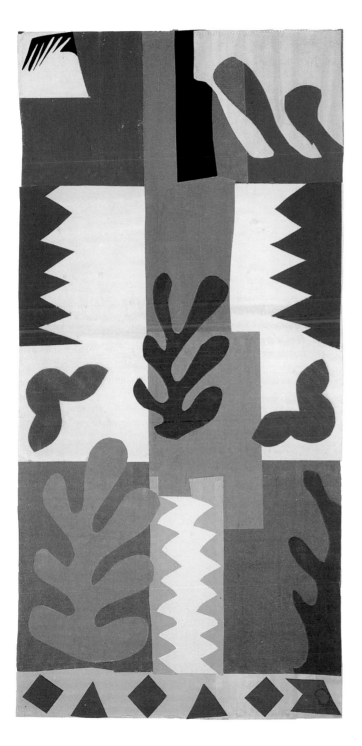

Page 50:
Mimosa. Maquette for a carpet produced in an edition of 500 by Alexander Smith and Sons, New York, 1951. Gouache cut-outs, 148 x 96.5 cm

Left:
The Screw, 1951. Gouache cut-outs, 172 x 82 cm. Private collection

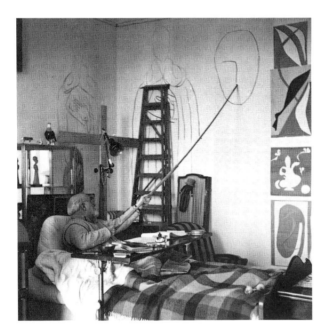

Top:
The Bees, 1948. Gouache cut-outs,
101 x 24 cm. Musée Matisse,
Nice

Left:
Matisse drawing from his bed, in
his room in Nice, 1950

Page 53:
Pale blue stained-glass window.
Maquette for the Dominican Cha-
pelle du Rosaire at Vence, 2nd
state. Double window of the sanc-
tuary, 1948–1949. Gouache cut-
outs, 515 x 252 cm. Centre Na-
tional d'Art et de Culture Georges
Pompidou, Paris

Like Cutting Glass

Speaking of the stained-glass windows of his chapel, Matisse again referred to *Jazz*: "Those are stained-glass colours. I cut the gouached paper as one cuts glass; it is just that, there, the colours are arranged to reflect the light, whereas for the stained-glass they must be arranged so that the light comes through them."

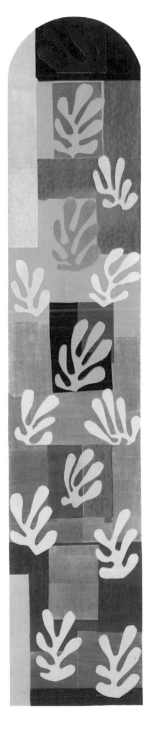
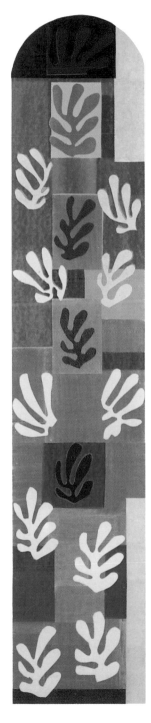

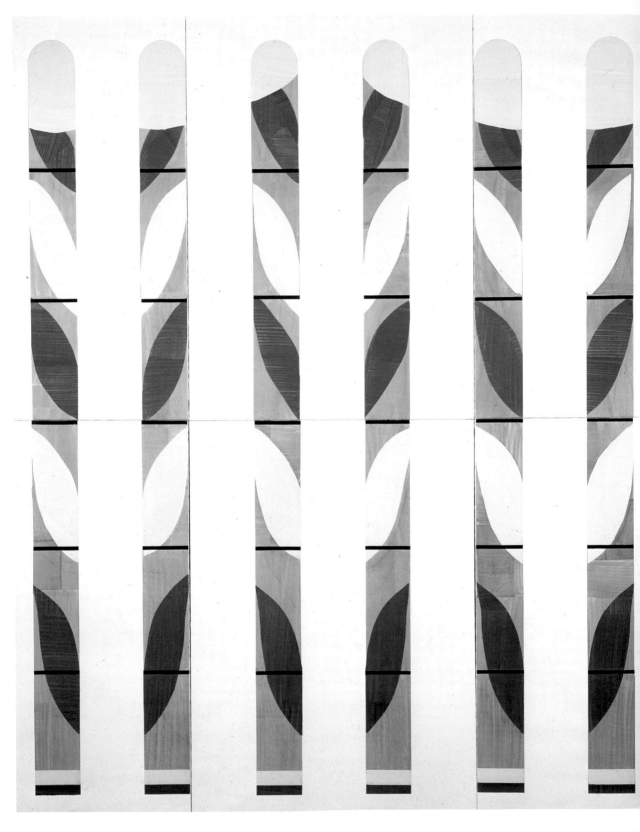

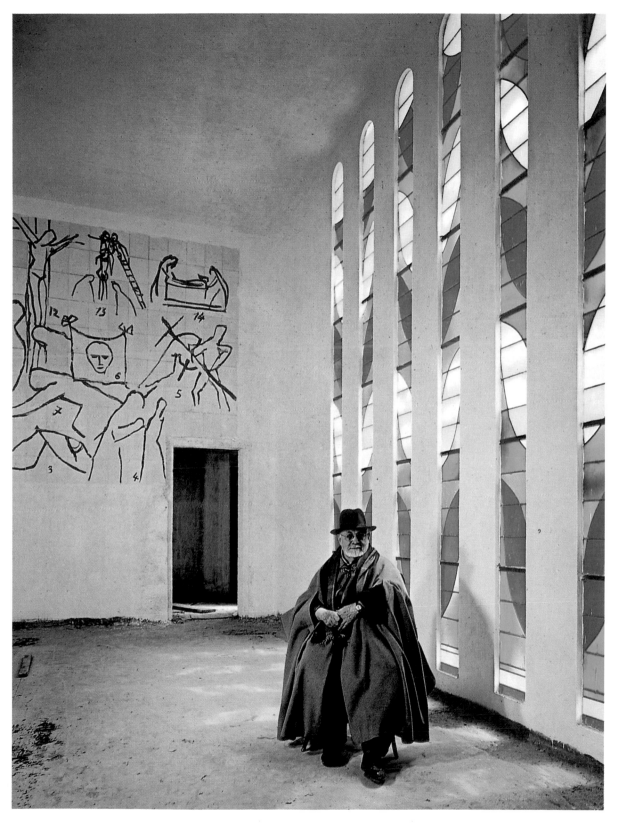

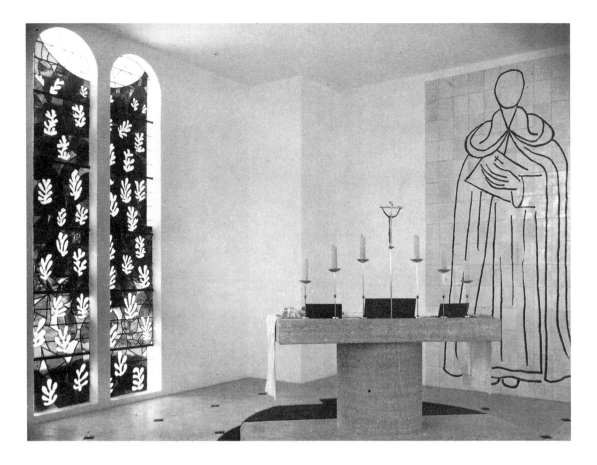

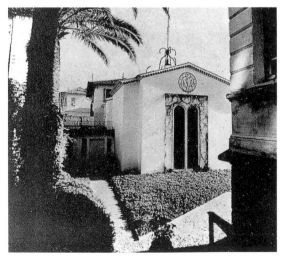

Pages 54 and 55:
The Tree of Life. Final maquette
(3rd state) of the six windows of
the nave, 1949. Gouache cut-outs,
515 x 515 cm. Vatican Museum,
Rome
Matisse in front of *The Tree of Life*
at the Chapelle du Rosaire, Vence,
1949

The altar, with the stained-glass
window of *The Tree of Life* to the
left and *St Dominick*, drawn by
Matisse from his bed, to the right

The entrance to the Chapelle du Ro-
saire, Vence, consecrated 25 June
1951, by the Bishop of Nice

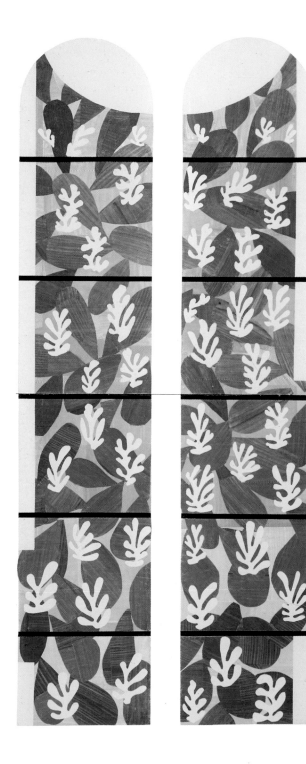

The Tree of Life, Symbol of the Golden Age

The preparatory drawings for the stained-glass windows were thus created using gouache cut-outs. After long reflection, the theme was drawn from the Book of Revelation: "In the midst of the street of it, and on either side of the river, was there the tree of life, which… yielded her fruit every month: and the leaves of the tree were for the healing of the nations". The Tree of Life, symbol of the Golden Age! The tree, the flower! Is there any more beautiful leitmotif in the work of Matisse than this culmination of his habitual themes?

Picasso was furious that Matisse was creating a church. "Why not do a market instead? You could paint the fruit and the vegetables!" Matisse confided to a nun: "But I don't care: I have greens greener than pears and oranges more orange than pumpkins…"

The Tree of Life, Double window of the sanctuary, 1949. Gouache cut-outs, 515 x 252 cm. Vatican Museum, Rome

Nude Study, 1947. Charcoal and stump, 36 x 27 cm. Private collection

Nude Study. Charcoal and stump, 30 x 26 cm. Private collection

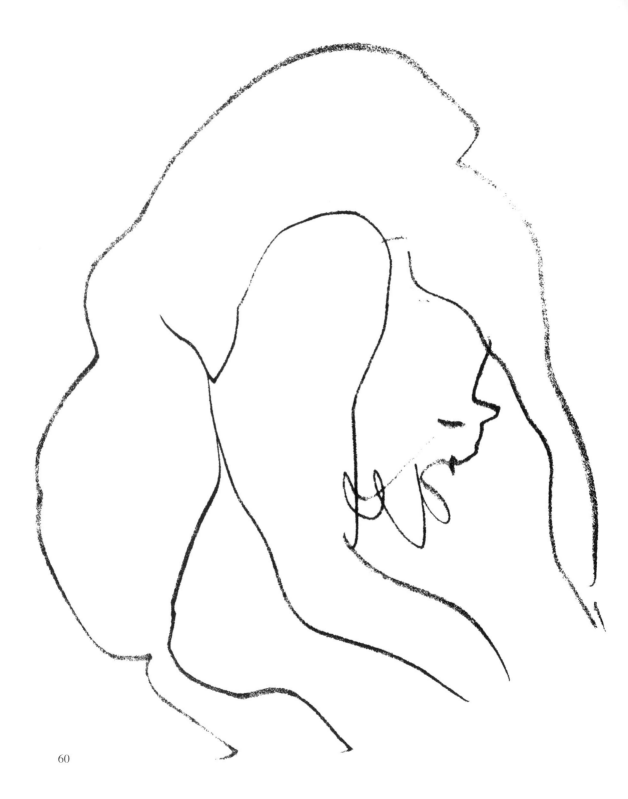

60

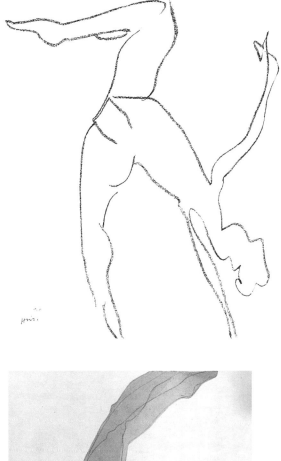

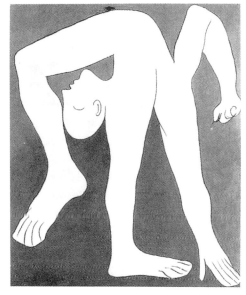

Dance and "Joie de vivre"

The pleasure that Matisse took in painting the joy of living made dance one of his major themes. "I had had this dance in me for a long time, and I had put it into 'La joie de vivre', then in the first big composition [for Shchukin]… It was like a rhythm within me that carried me along."

The Idea of Immensity

Dance is a constant in the work of Matisse, and a whole series of canvases and cut-outs later derived from it. They are all works of extreme plastic contortion and rigorous composition. The human element is trimmed, tempered, if not indeed eliminated. Above all, Matisse sought to give, within a confined space, the idea of immensity.

Acrobats, 1952. Stencil

Page 63:
Large Woman Acrobat, 1952.
Paint-brush and Indian ink,
105 x 75 cm. Musée Matisse, Nice

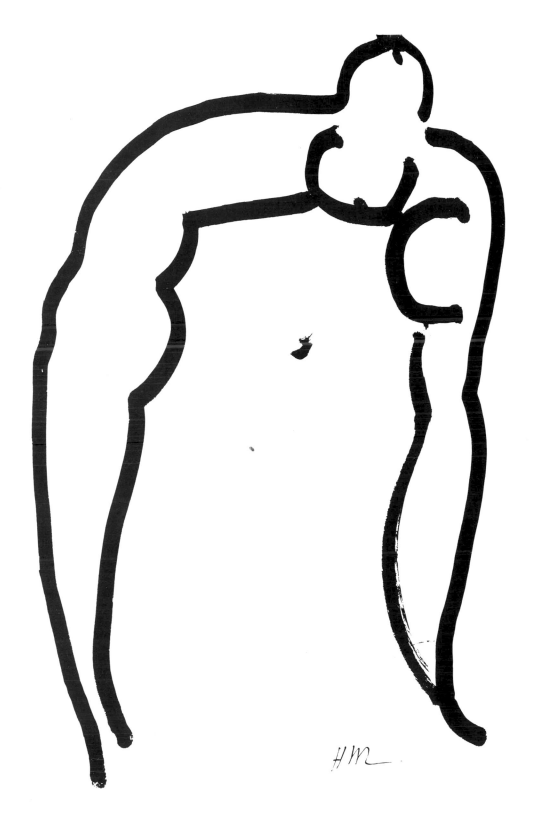

HM

63

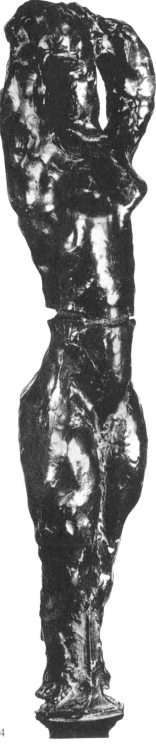

64

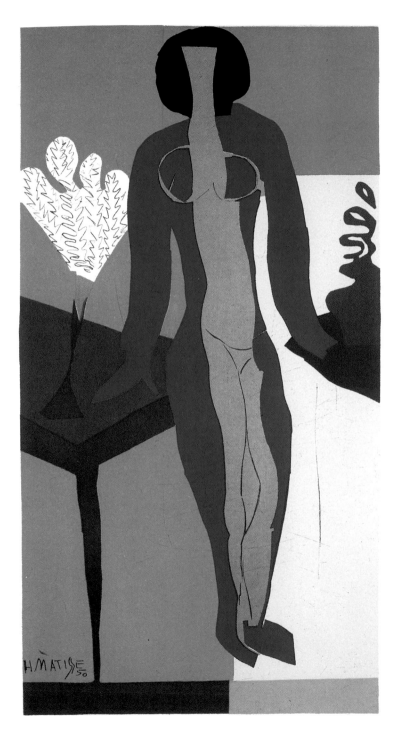

The Old Sage and the Young Giantesses

An old sage surrounded by young giantesses ("plane trees" in his description), Matisse endlessly modelled them, cut them out in vast sheets of coloured paper, or drew them in an earthly paradise reconstituted in the middle of the 20th century.

Standing Nude (Katia), with broken waist, 1950. Bronze, height: 45 cm tall

Zulma, 1950. Stencil

Nude with Oranges, 1953. Brush drawing and gouache cut-outs, 155 x 108 cm. Centre Georges Pompidou, Paris

Large Nude, 1952. Brush and Indian ink, 210 x 80 cm. Private collection

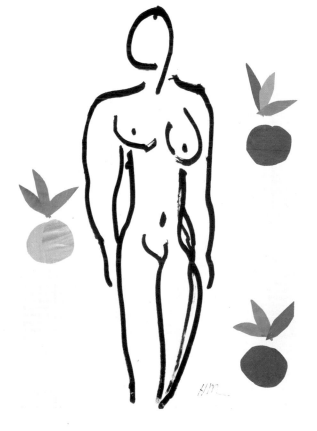

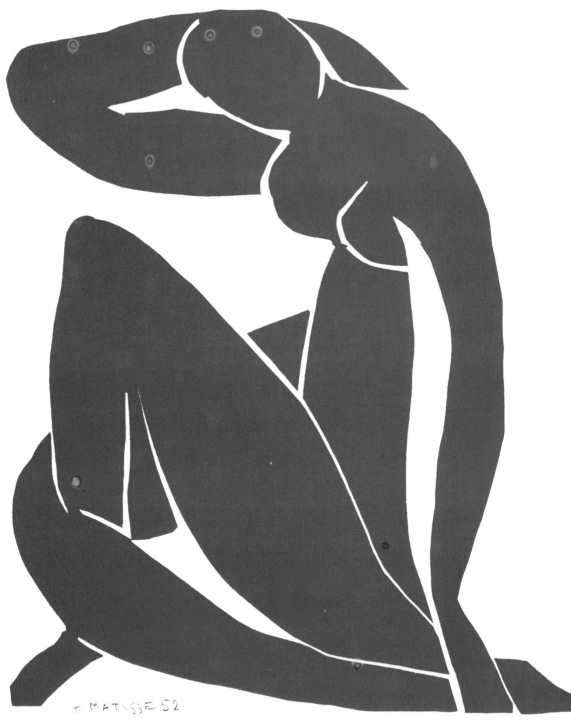

H MATISSE 52

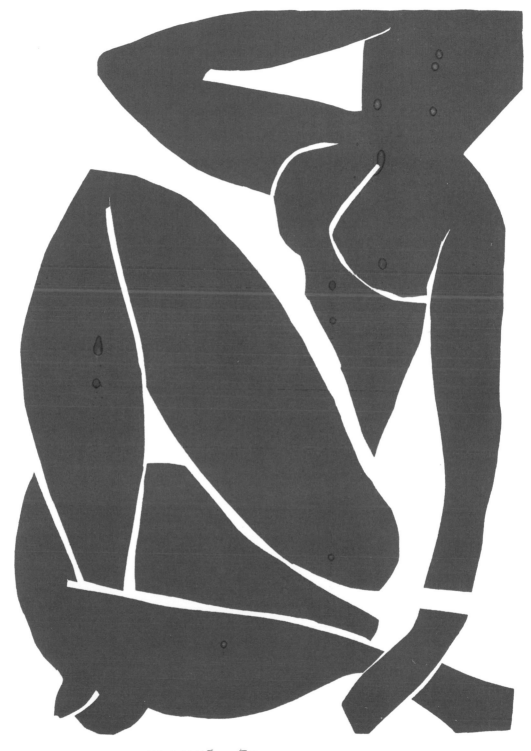

HMATISSE 52

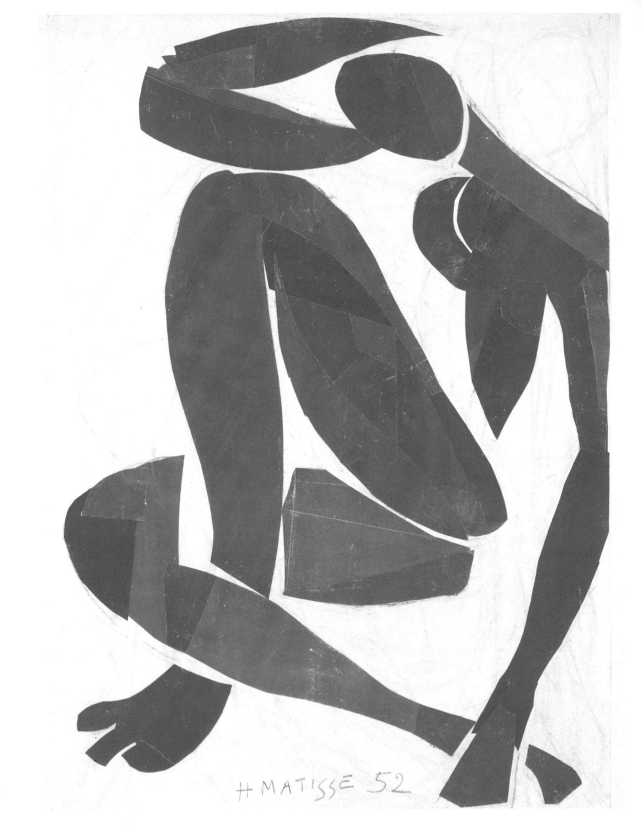

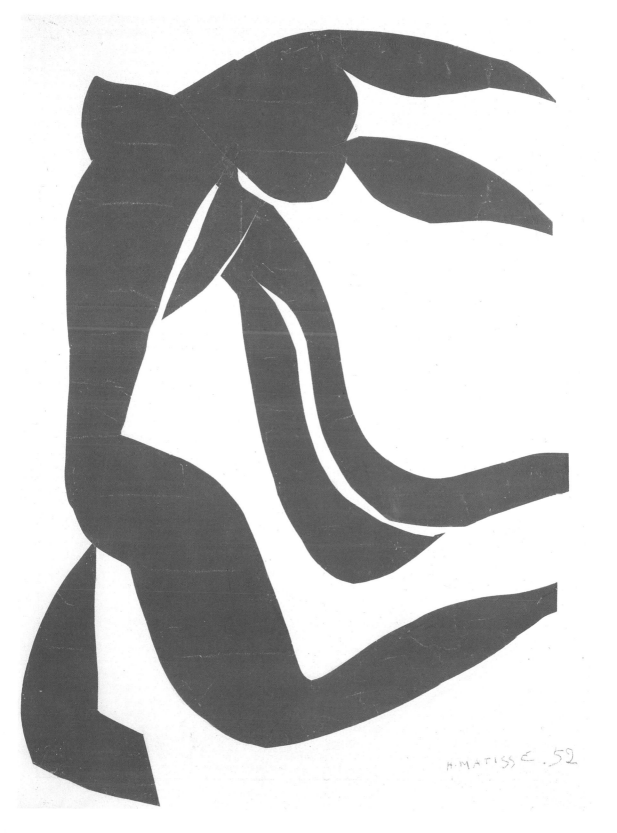

H·MATISSE ·52

Pages 66–69:

Blue Nude II, 1952. Stencil

Blue Nude III, 1952. Stencil

Blue Nude IV, 1952. Gouache

cut-outs, 102.9 x 76.8 cm.
Musée Matisse, Nice

The Head of Hair, 1952. Gouache cut-outs, 108 x 80 cm. Private collection

Emblems of the Female Body

Dancer or acrobat, the figure of Woman finds in the oeuvre of Matisse its definitive sign. The "Blue Nudes", veritable emblems of the female body, act on the intimate feelings like the stroke of a gong, their power the greater for their simple inner form. The interstices of white suggest their kinship to sculpture. One thinks of the Lao-Tzu's words in the Tao Te Ching:

"Clay serves to make the vase. But only the space within allows its use."

Page 70 left:
Standing Blue Nude, 1952. Stencil

Page 70 right:
Blue Nude, Skipping, 1952. Stencil

Page 71:
Blue Nude with Green Stockings,
1952. Stencil

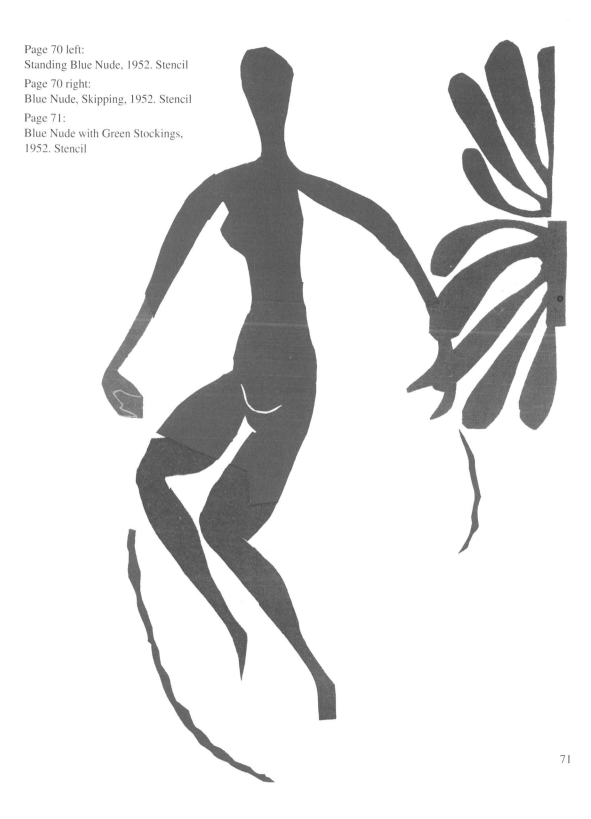

Vision of Earthly Paradise

S tanding Blue Nude, Blue Nude, Skipping, Blue Nude with Green Stockings (it is said that supplies of blue gouached paper were lacking that day, so the legs were finished with green and the arms with red) are stepping-stones in the creation of the great compositions. They recur in *The Swimming Pool* and each in turn was tried as a counterpart to the budgerigar before the "siren" was chosen in their place.

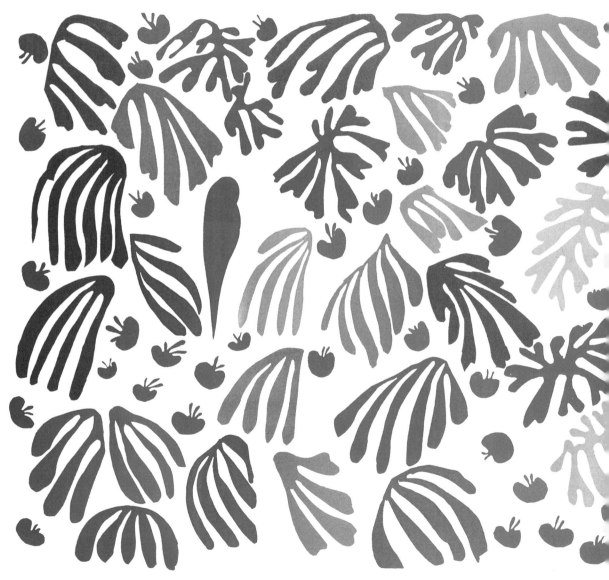

The Budgerigar and the Siren,
1952. Gouache cut-outs,
337 x 773 cm. Stedelijk Museum,
Amsterdam

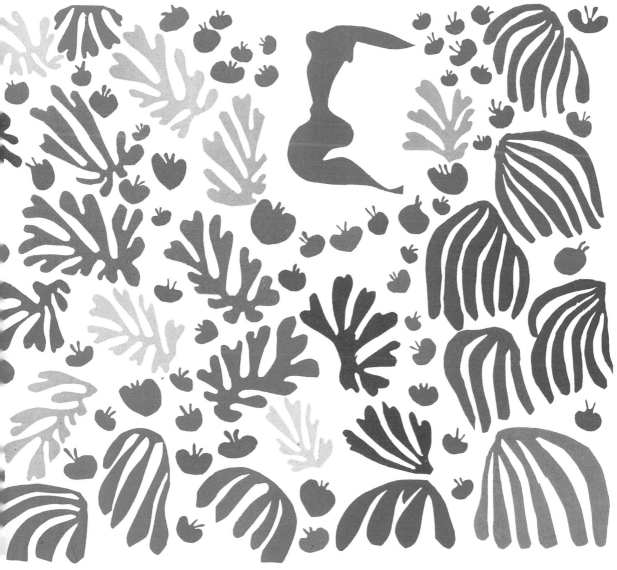

Top:
Large Decoration with Masks,
1953. Gouache cut-outs,
353.7 x 997 cm. National Gallery
of Art, Washington

Bottom:
Woman and Apes, 1952. Gouache
cut-outs, 72 x 286 cm. Museum
Ludwig, Cologne

Eve's Costume is the Uniform of Love

Matisse avowed that the woman of *Women and Apes* was a link between the plant on the left and the hominoid on the right. More than ever, Matisse's works of 1952–1953 suggest the Golden Age, the extraordinary garden of Earthly Paradise brimming with flowers and fruits among which, as myth prescribes, naked creatures wander. Is not Eve's costume the uniform of love?

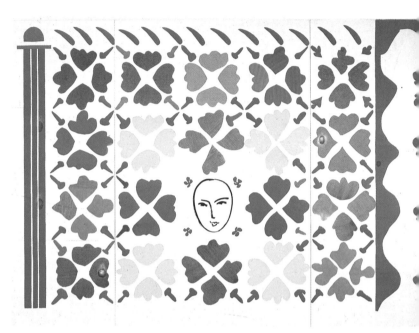

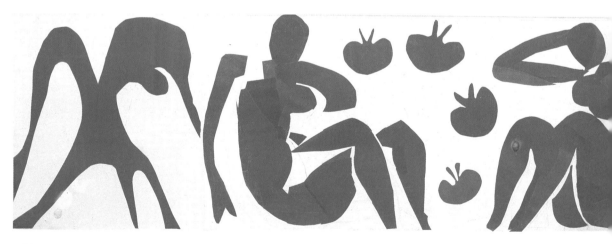

Right:
Woman with Amphora, 1953.
Gouache cut-outs, 164 x 48 cm.
Centre National d'Art et de Culture
Georges Pompidou, Paris

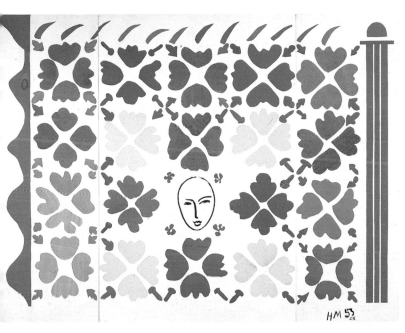

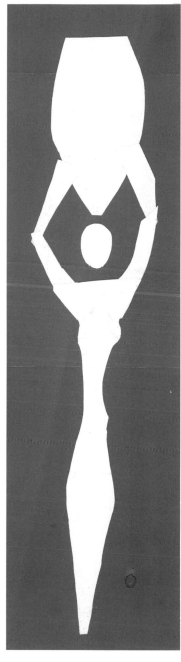

The Magical Creatures of Night

The Thousand and One Nights, like *Sea-Beasts* (p. 79), belongs to the group of works conceived as series of panels. by Scheherazade, the successive images follow the narrative order through a night punctuated by the Persian lantern first alight (white

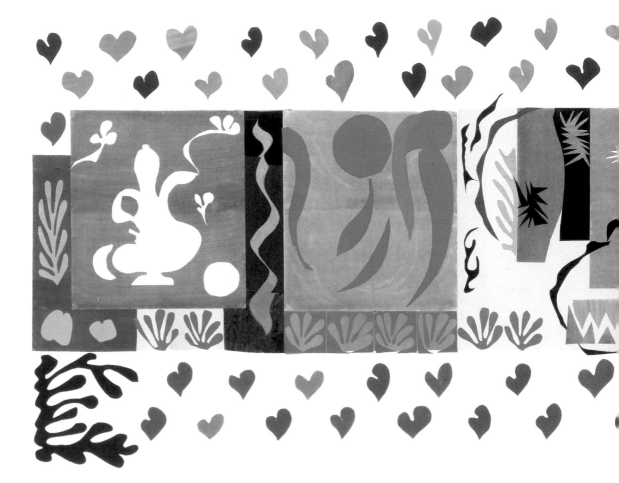

There are links between them: Matisse would pin up their component pieces by side on the wall of his studio in the hôtel Régina. Like a cartoon strip of the tale improvised on red), then extinguished (black on lemon). The broad ornamental border of hearts tells us clearly that this is a story of love. Deft as he was at using black to create light,

Matisse recounts the magical crea-
tures of night in the most dazzling
colours.

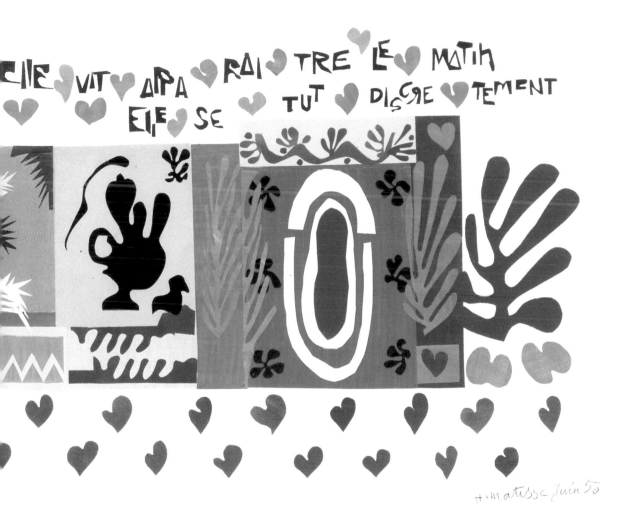

The Thousand and One Nights,
1950. Gouache cut-outs,
139.1 x 374 cm. The Carnegie
Museum of Art, Pittsburgh

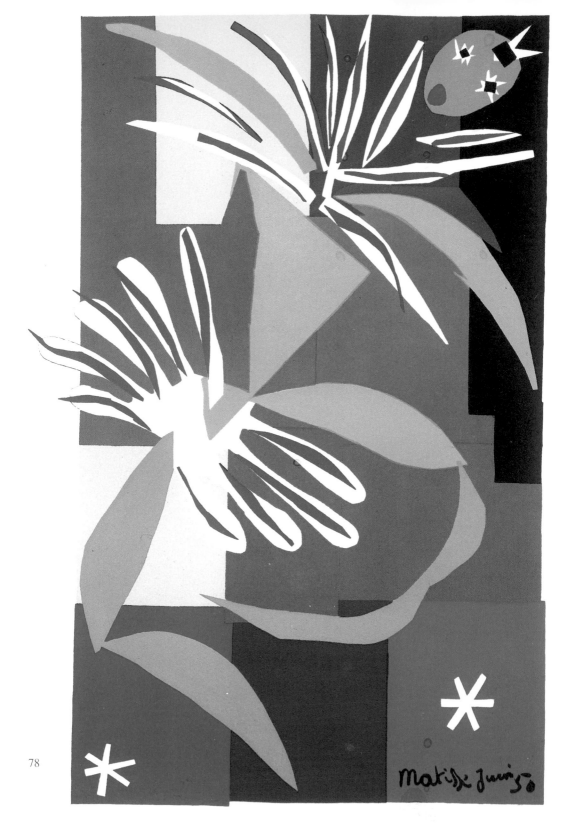

Page 78:
Creole Woman Dancing, 1950.
Gouache cut-outs, 205 x 120 cm.
Musée Matisse, Nice

Right:
Sea-Beasts, 1950. Gouache cut-
outs, 295.5 x 154 cm. National
Gallery of Art, Washington

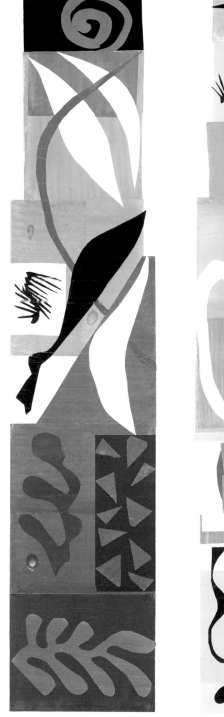

Pages 80/81:
The Swimming Pool, 1952.
Gouache cut-outs, 230 x 164.5 cm.
The Museum of Modern Art,
New York

les bêtes de la mer...
H. matisse 50

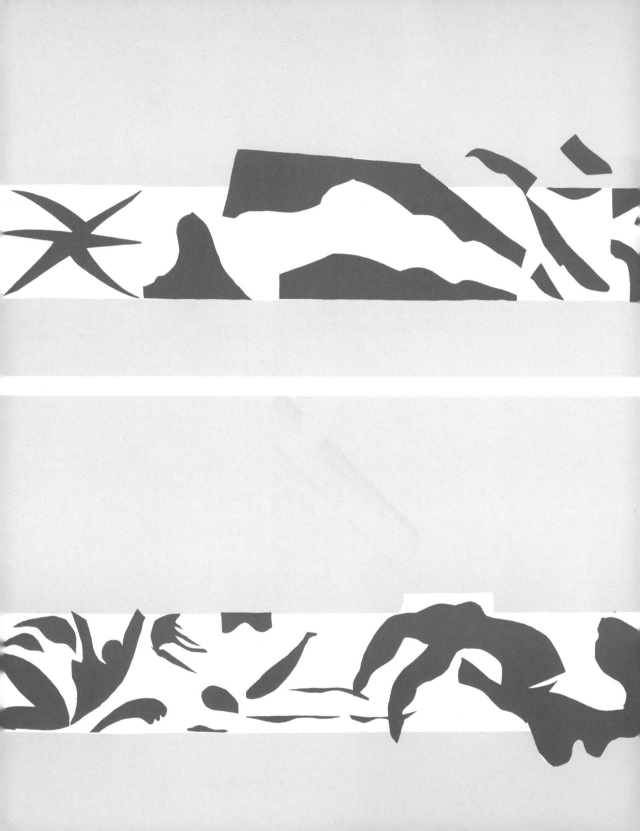

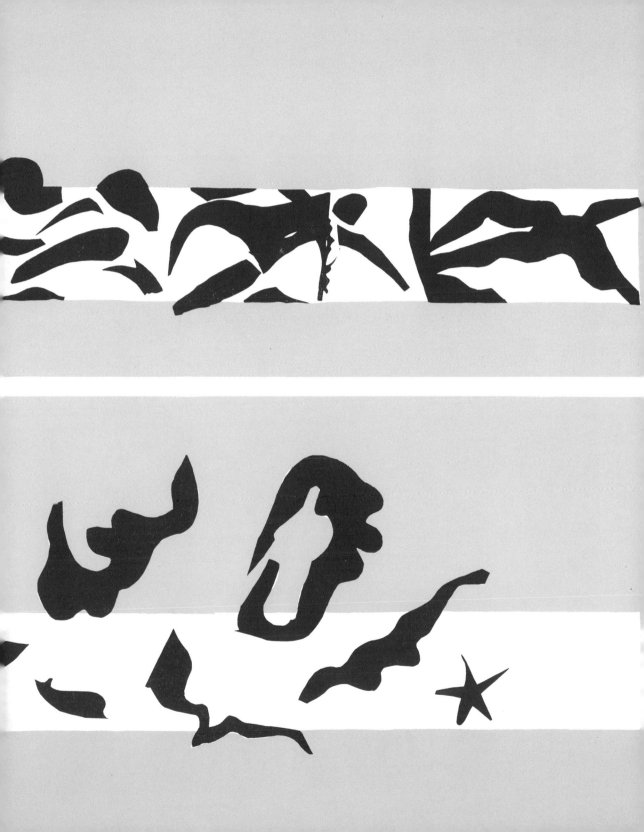

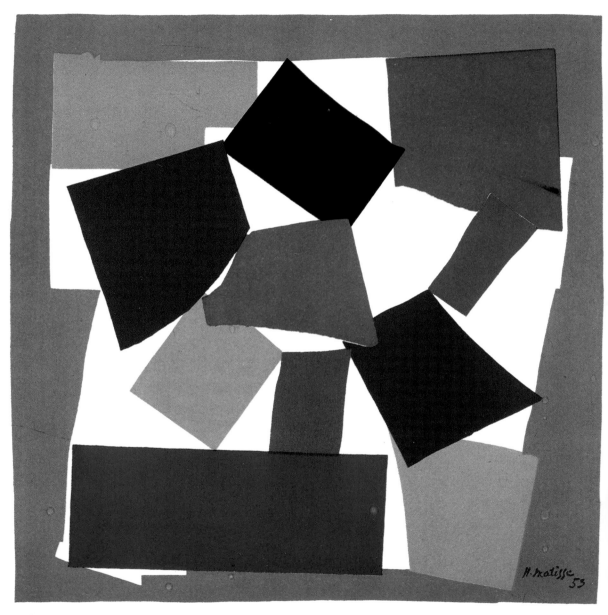

Flowering Ivy. Project for a
Stained-Glass Window, 1953.
Gouache cut-outs, 284.2 x 286.1 cm.
Museum of Fine Arts, Dallas

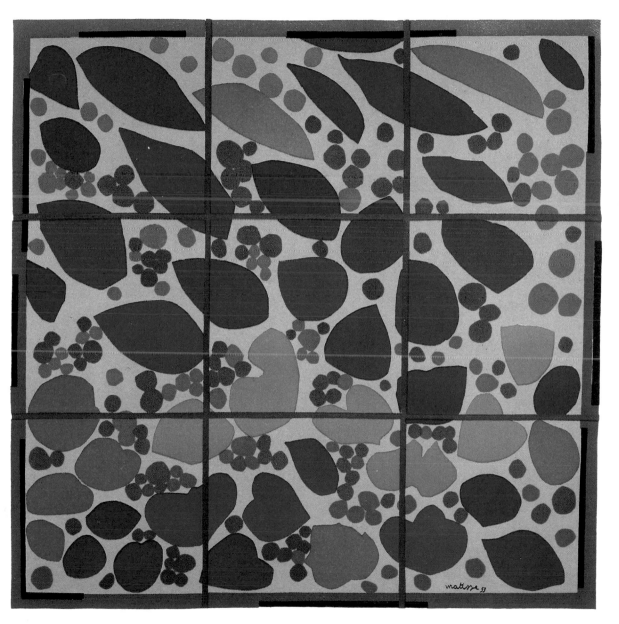

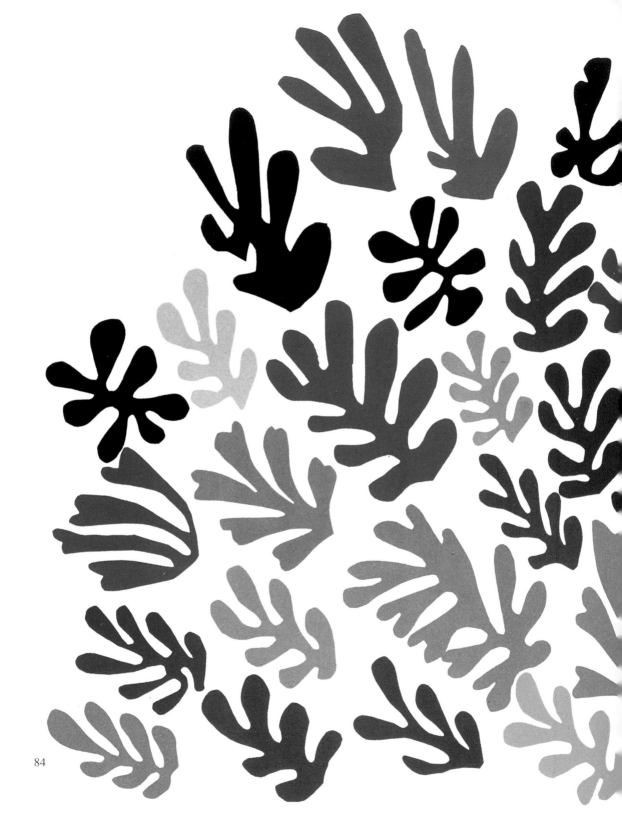

84

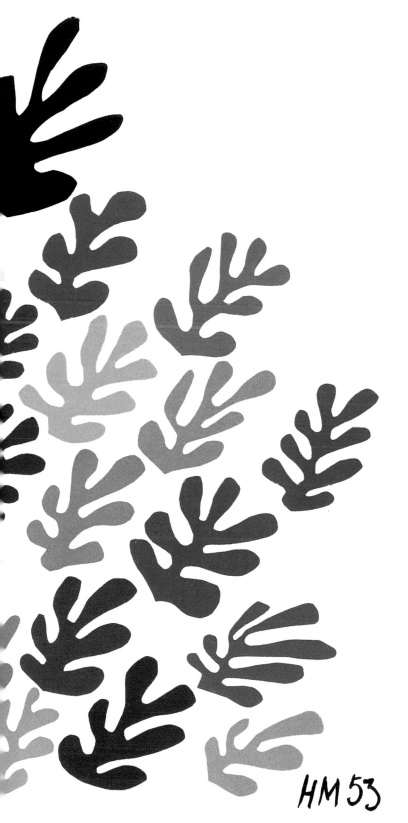

I Have Become a Budgie

A pair of scissors is a... wonderful instrument... Working with scissors in this paper is an occupation I can lose myself in... My pleasure in cutting things out grows ever greater. Why didn't I think of it earlier? More and more, I feel that one can express with the simplest cut-out what one might want to express as a draughtsman or painter... By entering into the object one comes into one's own. I had to make this budgerigar with coloured paper. Well, I have become a budgie! And in the work, I found myself. The Chinese sage said that one must grow with the tree. I know nothing truer... But I know that only much later will people realise how much what I do today was in accord with the future. Henri Matisse

The Spray, Maquette for a Ceramic Mural, 1953. Gouache cut-outs, 294 x 350 cm. University of California Art Galleries, Los Angeles

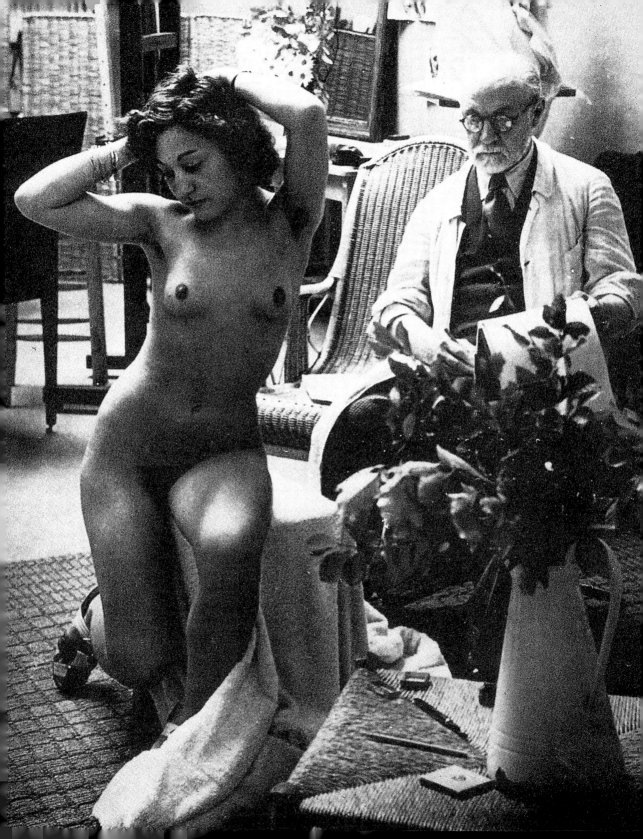

matisse HM.

BIOGRAPHY: 1869–1954

1869 Birth of Henri Emile Benoît Matisse at Cateau-Cambrésis on 31 December.
1887 Matisse arrives in Paris to study law.
1889 Takes a job as attorney's clerk in Saint-Quentin.
1890 After an appendectomy, he is confined to bed for months, and begins to draw to entertain himself. Immediately he has recovered, takes drawing lessons at the Maurice-Quentin Delatour School, while returning to Maître Duconseil's legal practice.
1891 Matisse gives up law to devote himself to his art. Moves to Paris and enrols at the Académie Julian where Bouguereau and Ferrier teach.
1892 Leaves the Académie Julian for Gustave Moreau's studio at the Ecole des Beaux-Arts. There meets Rouault, then Camoin and Manguin. He enrols for the Ecole des Arts Décoratifs.
1894 His mistress, Caroline Jobleau, gives birth to a daughter: Marguerite Emilienne.
1895 He is officially admitted to the Ecole des Beaux-Arts and spends the summer at Belle-Ile-en-Mer. Visits the Corot and Cézanne exhibitions at Paris.
1896 Exhibits for the first time at the Salon des Cent, organised by *La Plume*, and at the Salon de la Société nationale des Beaux-Arts of which he is an associate member. The French State buys *Woman Reading* for the Château de Rambouillet. Again spends the summer at Belle-Ile and meets the Australian John Russel who introduces him to Rodin and Pissarro. Takes an interest in Impressionist painting.
1897 End of his liaison with Caroline Jobleau. Meets Camille Pissarro; they become friends. *The Sideboard* is exhibited at the Salon de la Nationale and much criticised.
1898 He marries Amélie Pareyre and spends sev-

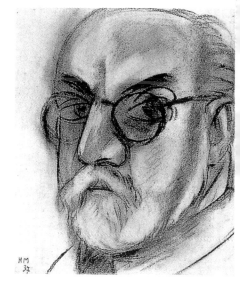

Self-portrait, Nice, 1937. Charcoal and stump, 34.5 x 28 cm. Private collection

Page 86:
Brassaï: Matisse and his model, 1939

Left:
Self-portrait, 1945. Pen and Indian ink, 51.5 x 40.5 cm. Private collection

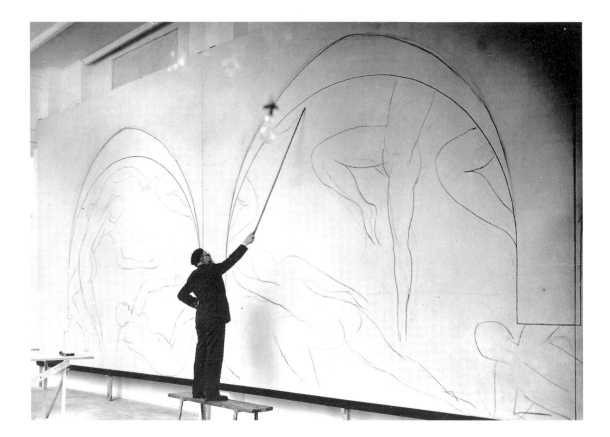

eral months in London (where he discovers William Turner), in Toulouse, and in Corsica.

1899 After the death of Gustave Moreau, works for a while under the directon of Cormon, and creates his first sculptures. Buys Cézanne's *The Three Bathers*, Gauguin's *Head of a Boy* and a Rodin cast from Vollard. Birth of his son Jean.

1900 Major financial problems. Another child is born: Pierre. Matisse works at the Académie de la Grande Chaumière, under the direction of Antoine Bourdelle; also attends the workshop of Eugène Carrière, where he meets André Derain and

Jean Puy. His wife opens a fashion boutique.

1901 Exhibits at the Salon des Indépendants. Derain introduces him to Maurice de Vlaminck.

1902 One-man exhibition at Berthe Weill's. Toulouse-Lautrec retrospective at the Salon des Indépendants.

1903 Matisse takes part in the first Salon d'Automne and makes his first etchings. A Gauguin retrospective follows Gauguin's death.

1904 First exhibition at Ambroise Vollard. Spends part of the summer in Saint-Tropez, with Signac and Cross; paints *Luxe, calme et volupté* (Musée d'Orsay), experimenting with neo-impressionist technique.

1905 Spends the summer at Collioure with Derain. Exhibiting at the Salon d'Automne, he, Marquet, de Vlaminck, Derain, Van Dongen and others cause uproar with their juxtaposed planes of pure violent colours. The critic Louis Vauxcelles having dubbed them "fauves" ("wild beasts"), the group immediately adopts the term in defiance. Matisse meets the Stein family, who buy *Woman with Hat*, the painting that triggered the scandal. Signac buys *Luxe, calme et volupté*.

1906 Takes part in the Salon de la Libre Esthétique in Brussels and a further Fauve exhibition at the Salon d'Automne. Matisse

meets Picasso at Gertrude Stein's; Picasso shows him for the first time an African sculpture which was to influence *Les Demoiselles d'Avignon*.

1907 Travels in Italy with Léo and Gertrude Stein. Exchanges pictures with Pablo Picasso, who is working on *Les Demoiselles d'Avignon*.

1908 Starts an open drawing course at the Convent des Oiseaux, then at the hôtel de Biron, to which foreign students come in droves. The class closed in 1911. Exhibits at the first Golden Fleece Salon in Moscow. Publishes "Notes of a Painter" in *La Grande Revue*.

1909 Exhibition of his works in Berlin, in the gallery of Paul Cassirer. The Russian collector Shchukin commissions two large decorative panels: *Dance* and *Music*.
1910 First major exhibition, at the Bernheim-Jeune gallery. Visits Munich with Marquet for the Islamic art exhibition, then travels in Spain. First exhibitions in London and New York.
1911 On Shchukin's invitation, goes to New York to be present at the installation of *Dance* and *Music;* discovers Russian icons, which become a great source of inspiration.

1912 Twice travels in Morocco with Marquet and Camoin.
1913 Some works by Matisse are exhibited at the Armory Show in New York and at the Berlin Sezession.
1914 Moves to Collioure with his family. Marquet joins them; they meet Juan Gris, to whom Matisse is of financial assistance. Matisse takes violin lessons. Paints *Notre-Dame* and *French Windows at Collioure*.
1916 Spends part of the winter at Nice. In Paris, takes part in a banquet given in honour of the "assassinated" poet Guil-

Page 88:
Matisse working on Dr Barnes's "Dance", Nice, 1931

Top:
Matisse and "Decorative Figure on Ornamental Background", 1926–1927

Bottom:
Nude Kneeling in Front of a Mirror, 1937. Pen drawing. Private collection

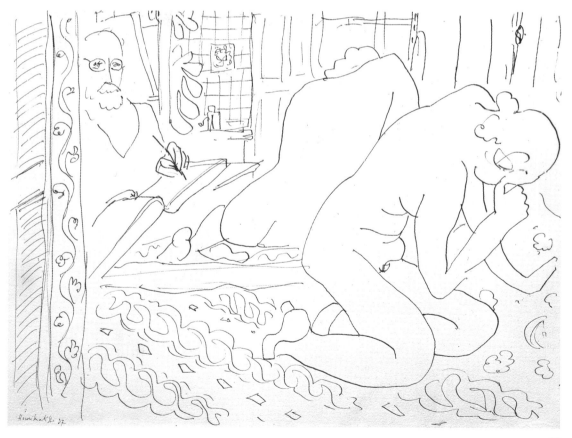

laume Apollinaire. Exhibition in London.

1918 Matisse decides to remain on the Côte d'Azur, which he considers a "paradise". Meets Renoir at Cagnes. Exhibits with Picasso at the Galérie Paul Guillaume.

1919 Stravinsky and Diaghilev request costumes and decor for *The Song of the Nightingale*, choreographed by Massine for the Ballets Russes, and performed in London. *The Black Table* with Antoinette for model.

1920 Marcel Sembat publishes the first monograph on Matisse. Decor and costumes for the *Song of the Nightingale* given by Diaghilev's Ballets Russes. Summer in London, then in Etretat.

1922 Series of *Odalisques*.

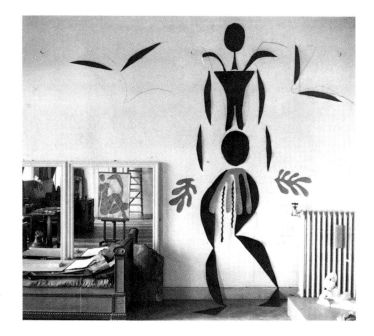

1923 Exhibition at the Galérie Paul Guillaume.

1924 Exhibition in New York, retrospective in Copenhagen.

1925 Exhibits several works at the Exposition internationale des Arts décoratifs et industriels modernes. Made Chevalier de la Légion d'honneur. *Decorative Figure on Ornamental Background*.

1927 In New York, Matisse retrospective (1890–1926) organised by his son Pierre at the Valentine Gallery. Receives the Carnegie Prize at Pittsburgh.

1930 In the USA, Matisse meets Dr Barnes, who commissions a large decorative mural for his museum. Ends his trip with a stay in Tahiti.

90

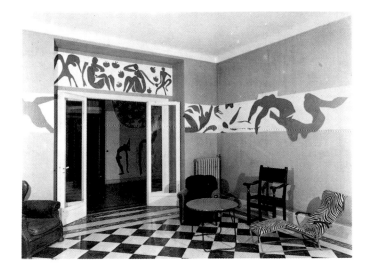

Page 90 top:
Matisse in Nice in 1952. On the wall, "The Negress" (in progress). In the mirror, a sketch of "Blue Nude IV"

Composition (The Velvets), 1947. Gouache cut-outs, 51.5 x 217.5 cm. Kunstmuseum, Basle

Matisse's dining room at the hôtel Regina, transformed into "The Swimming Pool" and peopled with "Women and Apes". Through the door the "Women Acrobats" and the "Pink Chasuble" are visible, 1952

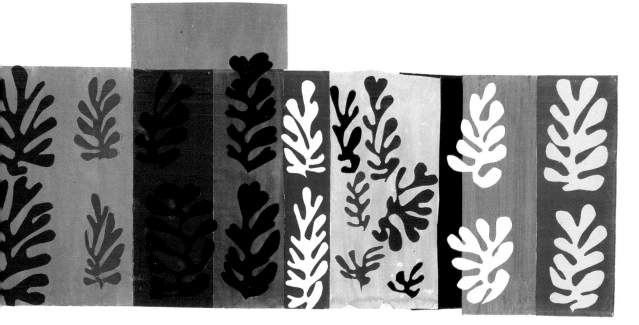

1931 Retrospective at the Museum of Modern Art, New York. Albert Skira asks him to illustrate works by Stéphane Mallarmé.
1933 Returns to the USA for the installation of *Dance* at Merion. Meets Léger.

1934 He works on illustrations to Joyce's *Ulysses*.
1935 His assistant Lydia Delectorskaya becomes his model, in particular for *The Dream* and *Pink Nude*. Visits Bonnard at Cannet.
1936 The Paris Munici-

pality buys the first version of *Dance*, through the good offices of Raymond Escholier, Director of the Petit Palais.
1937 He starts work on the costumes and decor of *Red and Black* (or *Strange*

Farandole) for the Ballets Russes of Monte Carlo. For the first time, he uses the technique of cutting out gouached paper for certain of the maquettes.
1938 Publication of an interview, "Listening to

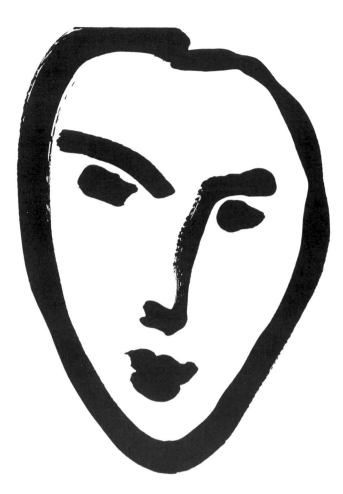

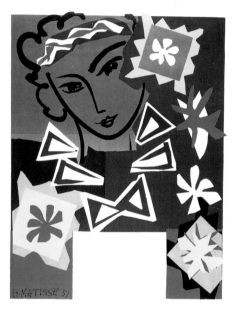

Matisse", by Montherlant, in *L'Art et les artistes.* Picasso-Matisse Exhibition at the Museum of Modern Art, Boston.
1939 Lavishes praise on Jean Renoir for his film *La Règle du Jeu.*
1940 Decides to remain in France. Separates from Amélie. Paints *The Romanian Shirt* and *The Dream.*
1941 Ill with cancer, he enters the Clinic du Parc in Lyon. Suggests illustrating

the *Amours* of Pierre de Ronsard to Skira. Meets Aragon and Elsa Triolet.
1942 His nurse, Monique Bourgeois – later Sister Jacques-Marie – becomes his model. He uses the technique of cut-outs and starts the *Jazz* series, published in 1947. On the evacuation of Nice, goes to Vence.
1943 Moves permanently to Vence, to the Villa "Le Rêve", where he lives till 1948.

1944 Madame Matisse is imprisoned and his daughter deported for acts of resistance.
1945 Major retrospective at the Salon d'Automne. The French State buys six paintings for the new Musée d'Art Moderne. Exhibits with Picasso at the Victoria and Albert Museum, London. Exhibits recent pictures, with photos of their successive stages, at the Maeght Gallery.

1946 Cartoons for the tapestries *Oceania, Sky* and *Oceania, Sea.*
1947 Made Commandeur de la Légion d'honneur. First meeting with the Dominican friar Rayssiguier concerning the decoration of the Chapelle du Rosaire at Vence. Deaths of Bonnard and Marquet.
1948 Devotes himself to the decoration of the Chapelle du Rosaire.
1950 Matisse receives First

H.M.

Prize at the XXVth Venice Biennale where he is the French representative.
1951 The Chapelle du Rosaire at Vence is consecrated. Léger designs the stained-glass windows of the church of Andincourt. Exhibitions at the Museum of Modern Art, New York, at Cleveland, Chicago, San Francisco and Tokyo.
1952 Inauguration of the Musée Matisse at Cateau-Cambrésis, the town of his birth. Creates *The Sadness of the King* and the series of *Blue Nudes*.
1954 Giacometti draws a dozen portraits of Matisse for the Monnaie de Paris. Matisse dies 3 November at Nice and is buried in the Cimiez cemetery in a plot donated by the town.

INDEX

pages

A

Acrobatic Dancer, 1931–1932 60
Acrobats, 1952 62

B

Bees (The), 1948 52–53
Blue Nude I, 1952 17
Blue Nude II, 1952 66
Blue Nude III, 1952 67
Blue Nude IV, 1952 68
Blue Nude, Skipping, 1952 70
Blue Nude with Green Stockings, 1952 71
Budgerigar and the Siren (The), 1952 72–73

C

Chinese Fish, 1951 13
Christmas Night, 1952 49
Composition (The Velvets), 1947 90–91
Creole Woman Dancing, 1950 78

D

Dance, 1938 6
Dance, 1931–1933 8–9
Dancer, 1937 8
Dancing Woman, 1931–1932 61

F

Face, 1952 92
Flowering Ivy, 1953 83
Foliage, 1948 95

H

Head of Hair (The), 1952 69

J

Jazz (published in 1947):
 Forms. White Torso and Blue Torso, 1944 11
 The Toboggan, 1943 21
 The Clown, 1943 27
 The Circus, 1943 28–29
 Mr Loyal, 1943 31
 The Nightmare of the White Elephant, 1943 32
 The Heart, 1943–1944 32
 The Wolf, 1944 33
 The Horse, the Squire and the Clown,
 1943–1944 34-35
 Icarus, 1943 37

The Burial of Pierrot, 1943 38–39
The Codomas, 1943 40
The Woman Swimming in the Aquarium,
1944–1946 41
Destiny, 1943–1946 41
The Sword-Swallower, 1943–1946 42
The Cowboy, 1943–1946 43
The Knife-Thrower, 1943–1946 44–45
The Lagoon, 1944 46–47

L

Large Decoration with Masks, 1953 74–75
Large Woman Acrobat, 1952 63

M

Madame de Pompadour…, 1951 92
Mimosa, 1951 50

N

Negress (The), 1952–1953 15
Nude Kneeling in Front of a Mirror, 1937 89
Nude with Oranges, 1953 65

P

Pale blue stained glass-window, 1948–1949 53
Polynesia, The Sky, 1946 48

R

Red Dancer, 1938 25

S

Sadness of the King (The), 1952 14
Sea-Beasts (The), 1950 79
Self-portrait, 1934–1935 93
Self-portrait, 1937 87
Self-portrait, 1945 87
Screw (The), 1951 51
Small Torso, 1929 10
Small Dancer on Red Background, 1938 24
Small Thin Torso, 1929 10
Snail (The), 1952 82
Spray (The), 1953 84–85
Standing Blue Nude, 1952 70
Standing Nude (Katia), with broken waist, 1950 64
Strange Farandole (ballet), 1938 22
Swimming Pool (The), 80–81

T

Thousand and One Nights (The), 1950 76–77
Tree of Life (The) – 6 windows, 1949 54–55
Tree of Life (The) – double window, 1949 57

Two Dancers, 1938 20

V
Venus with Shell, 1930 16
Verve. Cover of 1st number, 1937 18
Verve. Cover of 13th number, 1945 20

W
Wave (The), 1952 95
Woman with Amphora, 1953 75
Woman Acrobat, 1952 93
Women and Apes, 1952 74–75

Z
Zulma, 1950 64

The Wave, c. 1952
Gouache cut-outs,
51.1 x 158.5 cm. Musée
Matisse, Nice.
Foliage. Lithography for the
Ronsard Anthology, pub-
lished in 1948.

ESSENTIAL BIBLIOGRAPHY

I. By Matisse

Matisse, Henri: *Ecrits et propos sur l'art*, edited by Dominique Fourcade, Hermann, Paris, 1972.

II. Works Illustrated by Matisse

Reverdy, Pierre: *Les Jockeys camouflés*, drawings, A La Belle Edition, Paris, 1918.
Vildrac, Charles: *Cinquante dessins*, drawings, published by the artist, Paris, 1920.
Mallarmé, Stéphane: *Poésies*, etchings, Skira, Lausanne, 1932.
Joyce, James: *Ulysses*, etchings, New York, 1935.
Montherlant, Henry de: *Pasiphaé*, lino-cuts, Fabiani, Paris, 1944.
Lettres de la religieuse portugaise, lithographs, Tériade, Paris, 1946.
Reverdy, Pierre: *Visages*, lithographs, Ed. du Chêne, Paris, 1946.
Rouveyre, André: *Repli*, lithographs, Ed. du Bélier, Paris, 1947.

Baudelaire, Charles: *Les Fleurs du mal*, etchings, wood engravings and photo-lithographs, La Bibliothèque Française, Paris, 1947.
Matisse, Henri: *Jazz*, stencil prints of original cut-outs, Tériade, Paris, 1947.
Les Miroirs profonds, various poems, drawings, Maeght, Paris, 1947.
Kobler, Jacques: *Le Vent des épines*, drawings by Matisse, Bonnard, and Braque, Maeght, Paris, 1947.
Florilège des Amours de Ronsard, lithographs, Skira, Paris, 1948.
Tzara, Tristan: *Midis gagnés*, drawings, Denoël, Paris, 1948.
D'Orléans, Charles: *Poèmes*, colour lithographs, Tériade, Paris, 1950.

III. Main Recent Monographs

Greenberg, Clément: *Henri Matisse*, Abrams, New York, 1953.
Diehl, Gaston: *Henri Matisse*, Pierre Tisné, Paris, 1954.

Reverdy, Pierre, and Duthuit, Georges: *The Last Works of Henri Matisse*, New York, 1958.
Ferrier, Jean-Louis: *Matisse*, Hazan, Paris, 1961.
Duthuit, Georges: *Le Feu du signe*, Skira, Geneva, 1962.
Selz, Jean: *Henri Matisse*, Flammarion, Paris, 1964.
Lassaigne, Jacques: *Matisse*, Skira, Geneva, 1966.
Hommage à Henri Matisse, XXe siècle , Paris, 1970.
Diehl, Gaston: *Henri Matisse*, Nouvelles Editions Françaises, Paris, 1970.
Aragon, Louis: *Henri Matisse*, Roman, Gallimard, Paris, 1971.
Elsen, Albert E: *The Sculpture of Henri Matisse*, Abrams, New York, 1972.
Barr, Alfred H. Jr: *Matisse, His Art and His Public*, Secker and Warburg, London, 1975.
Guichard-Meili: *Matisse, gouaches découpées*, Hazan, Paris, 1983.
Duthuit-Matisse, Marguerite, and Duthuit, Claude:

Henri Matisse, catalogue raisonné de l'œuvre gravé, edited with the assistance of F. Garnaud, Paris, 1984.
Schneider, Pierre: *Matisse*, Flammarion, Paris, 1984.
Delectorskaya, Lydia: *Henri Matisse, peintures de 1935–1939*, Maeght, Paris, 1986.
Monod-Fontaine, Isabelle: *Matisse: catalogue des œuvres de Henri Matisse (1869–1954)*, Centre Georges Pompidou, Paris, 1989.
Essers, Volkmar: *Henri Matisse*, Taschen, Cologne, 1989.
Jacobus, John: *Matisse*, Cercle d'Art, Paris, 1989.
Matisse au Maroc, peintures et dessins, 1912–1913, Adam Biro, Paris, 1990.
Izerghnina: *Matisse, œuvres des musées Pouchkine et de l'Ermitage*, Cercle d'Art, Paris, 1990.
Néret, Gilles: *Matisse*, Nouvelles Editions Françaises, Paris, 1991.
Elderfield, John: *Henri Matisse: a Retrospective*, Thames and Hudson, London, 1993.